COLOUR

RUDOLF STEINER

Three Lectures given in Dornach,
6th to 8th May, 1921
with Extracts from his Note-books

Translated by John Salter

RUDOLF STEINER PRESS

STEINER BOOK CENTRE
151 CARISBROOKE CRESCENT
NORTH VANCOUVER V7N 2S2
CANADA

Previously published by *Rudolf Steiner Publishing Co.*, London, and *Anthroposophic Press*, New York, 1935.

First Edition (new translation) by Rudolf Steiner Press, London, 1970. Translated from shorthand notes unrevised by the lecturer.

Reprinted (paperback) 1977
Reprinted 1979

The German title of the book containing these lectures *inter alia* is: *Das Wesen der Farben* (Rudolf Steiner Verlag, Dornach, Switzerland, Bibl. No. 291)

This English edition is published in agreement with the *Rudolf Steiner Nachlassverwaltung*, Dornach, Switzerland.

The cover shows the painting "Spring" by Hans Geissberger.
Copyright Walter Keller Verlag.

© 1971, Rudolf Steiner Press
ISBN 0 85440 310 8

MADE AND PRINTED IN GREAT BRITAIN BY
THE CAMELOT PRESS LIMITED, SOUTHAMPTON

Contents

From the Preface to the 1973 Edition of Das Wesen der
Farben 4

Translator's Foreword 8

1. Colour Experience: Image Colours 11
 6 May 1921
 *The concept of colour today — the living experience of
 colour — true character of colour experience — green,
 peach blossom, white (or light), black: image colours —
 summary*

2. Lustre and Image 24
 7 May 1921
 *A new colour circle — the nature of green and peach
 blossom — yellow, blue and red: the three lustre
 colours — the relationship between lustre and image
 colours — their relationship to the colour spectrum in
 physics — what is lustre? — lustres of the spirit, the
 soul and the living — significance for the art of painting*

3. Colour in Matter: Painting out of Colour 38
 8 May 1921
 What makes matter appear coloured? — reference to
 Occult Science *— the relationship of the sun to
 lustre colours — painting minerals, plants, animals
 and man — lustre, lustre-image, image-lustre, image —
 art, artist and theory — colour, ego, astral body*

Extracts from Rudolf Steiner's Notebooks 55

Notes 76

Bibliography 93

From the Preface to the 1973 Edition of Das Wesen der Farben

What Rudolf Steiner gave in these lectures of 1921 was the fruit of efforts he had been engaged in for forty years towards an understanding of the nature of colour. A close connection to the world of colour can indeed be traced through the whole of his life's work, and this fact becomes particularly poignant when we realise that it was Goethe's *Theory of Colour* that was the starting point for this life's work.

When Steiner was only twenty-one, his well-founded knowledge of the colour theories both of Goethe and of conventional physics persuaded his friend and teacher Karl Julius Schröer, then a well-known Goethe scholar, to suggest that he should be chosen to edit Goethe's scientific writings for the new Kürschner Edition of Goethe's works to be published in the eighteen-eighties. When the first volume, the morphological writings, appeared in 1884 it was immediately recognised by the experts of the day that Rudolf Steiner had comprehended Goethe's central importance in relation to the science of the organic. In his Introduction he demonstrated that Goethe had found the fundamental principles of organic science: "The processes in the starry heavens were observed long before Kepler and Copernicus, but they discovered the laws. The kingdom of organic nature was observed long before Goethe, but he discovered its laws. Goethe is the Copernicus and Kepler of the organic world."

Some years later Rudolf Steiner was also called to collaborate on the edition of Goethe's works to be published in Weimar, where he consequently lived from 1890 to 1897. At the turn of the year 1890–91, just after he had moved from Vienna to Weimar and exactly one hundred years after Goethe had commenced his studies on colour, the

volume on the *Theory of Colour* edited by Steiner appeared
in the Kürschner Edition. This contained a fundamental
introduction and nearly fifteen hundred longer or shorter
comments. In the Introduction Steiner wrote: "It would of
course not occur to me to attempt a defence of all the details
of Goethe's colour theory. It is the principle that I want to
see maintained. But it is also not my task here to derive from
his principles all the phenomena of the colour theory that
were still unknown in Goethe's day. Such a task could only
be achieved if I should one day be blessed with sufficient
leisure and means to write a Goethean theory of colour that
could do justice to the modern advances of natural science.
I should regard such a possibility as one of the most
gratifying of life's tasks."

Rudolf Steiner was never to write such a theory of colour.
Instead, however, he gave in his lectures and colour sketches
an abundance of suggestions that taken together could
furnish the base for an entirely modern work on colour—
possibly far exceeding any plan he might have had for a book.

After the publication in 1897 in the Kürschner Edition of
the volume "Materials for a history of the colour theory",
Rudolf Steiner's period in Weimar came to an end. There
followed from 1902 onwards the step from colour in the
physical world to colour in the world of soul and spirit.
This took place side by side with the beginning of Rudolf
Steiner's public advocacy of Anthroposophy. In his exposi-
tion of the path of spiritual scientific development in his
books *Theosophy* and *Knowledge of the Higher Worlds* he
began to describe the auric colours as they are seen with
spiritual perception shining with their own light.

A few years later came the first practical steps in finding
new ways of painting that could do justice to the artistic
representation of spiritual mysteries. In the first mystery
drama *The Portal of Initiation* (1910) the artist Johannes
Thomasius paints in a way that lets the 'forms' appear as
'the work of the colours.' Later Rudolf Steiner returned
again and again to this expectation and expression of the

need to paint out of the colours, out of the inherent qualities of the colours. In the following year he himself painted his first picture in this way for the easel of Johannes Thomasius in the second mystery play *The Soul's Probation*. The painter in the play says of this picture:

'Then in the gentle ether-red of spirit worlds
I tried to densify what is invisible,
by sensing how the colours nurse a longing
to see themselves in souls, transfigured into spirit.'
(trans. Ruth & Hans Pusch)

During the work on the first production of this play the actor playing the part of Thomasius asked Rudolf Steiner about the meaning of such a picture. Having hitherto only drawn and sketched, he now took up his brush and produced in tempera a painted work of art that signified the start of the new style: the form is to arise out of the work of the colours.

In January 1920 Rudolf Steiner began to give lectures with slides on the thoughts that lie behind the building of the first Goetheanum as well as on his own attempts at painting in the small cupola. The three lectures on the nature of colour contained in this book were given in response to requests from the other painters working in the Goetheanum at the time. Proceeding from Goethe's theory, which pre-supposes a single source for science and for art, Rudolf Steiner showed his listeners how to look at colours in a way that raised not only the theory but also practical technique into the realm of art. This way of knowing had also given rise to Goethe's thoughts on metamorphosis, thoughts which Rudolf Steiner held to be one of the greatest and most significant phenomena of recent intellectual life and which he so profoundly carried further, enabling the forms and colours of the first Goetheanum and also of eurythmy to unfold a new artistic style. Especially in eurythmy, the new art of movement in which every gesture is either light or dark and every mood of soul or music is felt to be coloured,

was born an experience of the laws and subtleties of colour metamorphosis.

These three lectures on the nature of colour are permeated by the processes of metamorphosis right down to the subtle suggestions of painting technique. In them is introduced the distinction between image and lustre colours, both entirely new concepts in the theory of colour. Observation of the differentiated colour qualities in the kingdoms of mineral, plant, animal and man, and also the metamorphosis of lustre into image and image into lustre colours, give the painter the basis on which to develop a painting technique in which the colour processes correspond to the kingdoms of nature.

The three lectures also deal with the significant question as to why matter appears coloured. Goethe did not really deal with this in his Theory of Colour "out of a certain intellectual honesty because he realised that with the means at his disposal he could not get to the heart of the problem: how is colour attached to solid matter?" And Rudolf Steiner felt that this question was really left unanswered also by the "customary knowledge of the time". It is a question, he says, which is "highly relevant to art, and painting".

He demonstrates how anthroposophical spiritual research could answer this question today because it recognises the links between earthly existence and the cosmic forces of creation and can show how the different stellar forces such as those of sun and moon bring about earthly colouring.

<div align="right">H. Raske and H. Wiesberger</div>

A great volume of artistic water has flowed over the aesthetic dams of the twentieth century since 1921 but most of the subsequent whirlpools and crosscurrents are implicit in the artistic revolution which was going on in the first two decades of the century, of which the building and painting of the first Goetheanum can now be seen to be an integral part. Some of Steiner's audience would be aware of the ferment enlivening the contemporary artistic scene, notably in Paris and Munich. Others, clearly, from the evidence of these lectures still required liberating from the post-Renaissance tradition of naturalism. The injunctions which we find in the third lecture to plunge freely into the fluid medium of paint now need no advocate. But the questing reader, still reeling a little from the clamour of artistic pundits at every museum bookstall, may find here the essential material upon which to found a more enduring artistic critique. The wilder shores of modernism have now assumed the dimensions of a tradition from which it is just as necessary to withdraw a pace now as it was two generations ago to challenge the canons of an earlier age.

Looking back from the vantage point of the present what is the essential contribution of these lectures to the swaying pictorial debate which is the course of twentieth-century painting? Different times and different eyes will give different answers but the following observations may provide a rough and ready compass to any who would welcome a bearing.

Even before the crucial first decade of the century two distinct tendencies stand out: Impressionism, the momentary capture of the eye's delight in its light and colour filled surroundings, and Expressionism, where the artist's feelings explode into paint on the canvas.

The mantle of Impressionism falls upon Cubism as the focus of attention shifts to an examination of the structure of things seen and the space they inhabit. In its turn Cubism rapidly yields to Abstract art which explores the structure of the picture space itself and the modulation of this space through areas of colour into a vehicle for rendering more intellectual emotions.

Expressionism pursues the cult of vitality into every kind of experience, spawning a hundred short-lived daughters by the way. Surrealism drives the quest behind the curtain of sleep and drugs. Action painting seeks to elevate the almost involuntary movements of the dripping brush from a semi-conscious realm to the clearer focus of an art.

The terminus of the abstract tendency is a calculating coldness and aridity from which finally all humanity is squeezed: of the other, an exuberance so private that often only a fanatical coterie can comprehend. At one end of the line art becomes inhuman, at the other all-too-human! Between, modern art shunts with much clanking of rolling stock. Sometimes with brilliant achievement, sometimes in wayward perversity, it strains about the fulcrum which is defined in these lectures and the extracts from the *Notebooks*.

For Steiner the artist's experience of colour is his compass to guide him between the Scylla of Expressionism and the Charybdis of Abstraction. Each colour and the conversation that passes between them is a unique and characteristic activity to which the artist grows sensitive. His gifts are placed at the disposal of the changing life of colour which he refrains from pressing into the service of naturalism or abstraction, or charging with the heaviest load of private feeling it will bear. In the inner space thus held open, as it were, the artist receives his inspiration—from the field of colour itself which, when liberated from the handcuffs of the senses, proves to share a common origin in a world of spirit with the human soul itself. Through colour, feeling is educated to mediate a pictorial experience of wider spiritual

validity than notched up private reactions or subconscious dalliance can achieve. Instead of abstract principles of composition and design, the meeting of coloured surfaces generates the form which the picture finally takes on as its independent existence. The painter's fundamental sense of expression, colour, is restored to its primacy; acting upon the artist's sensibility it ultimately determines both the content and form of the completed picture. Here both Expressionism and Abstraction unite in that freer and fuller form of the art of painting to which these lectures still point the way.

The foregoing remarks should be read for what they are— a very brief sketch of the main polarities which underlie the bewildering variety of modern art but which unite in many strange ways. It seeks only to give a point of reference for the reader's own exploration. The significant discoveries of modern painters in the free handling of colour, in the generation of telling images which lay bare the inner structure of the soul with its aspirations and failings, in the dialogue between the painter and the painted surface which leads to the emergence of form instead of the imposition of an already conceived form and many other achievements become readily understandable. Steiner's essential contribution is to lead over from artistic experience to a knowledge of what happens in the creative process whilst at the same time enhancing rather than diminishing the validity of the experience.

JOHN SALTER

Midsummer, 1968

COLOUR EXPERIENCE
IMAGE COLOURS

My dear Friends,

Colour, which is our subject for the next three days, concerns the physicist—although we shall not discuss this aspect just now. It also concerns, or should concern, the psychologist, the metaphysician, but it must above all concern the artist, the painter. If we look round at contemporary ideas about colour, however, we find that although the psychologist may have this or that to say about our subjective experience of colour, this contributes little to our understanding of its objective nature, a matter which is left entirely to the physicist. Moreover, there is little inclination to admit that art has anything decisive to say about the nature of colour—not at least for an objective understanding of coloration.

Nowadays people are very far from grasping the meaning of Goethe's often quoted aphorism: "He, to whom nature begins to unveil her open secrets, feels an irresistible longing for her worthiest interpreter, art."[1]

A person who, like Goethe, has a living experience of art has no doubt that what the artist says about colour is deeply connected with its real nature. Normally colour is regarded as belonging in the first place to the coloured surfaces we perceive, to the impressions we receive from the colours of nature. We can produce a certain range of colour with the familiar prismatic experiments and we can seek insight into the realm of colour in many other ways, too. But colour is still primarily regarded as a subjective impression. You know that physics has long had the habit (we might say bad habit) of maintaining that the coloured world we see around us is present only for our senses and that, if we are to speak objectively, colour is no more than

certain vibrations of the finest form of matter, known as the ether.

Those who think in terms of such definitions and explanations have no idea how their experience of colour is actually connected with a vibrating ether. But when people speak of the qualities of colour itself they refer only to the subjective impression. Then they look around for something else that is objective and in doing so they wander far away from colour. For in conjuring up all these ether vibrations nothing is left of the real stuff of our world of colour. In order to grasp colour objectively we must try to keep within the world of colour itself and not leave it; then we may hope to penetrate its real nature.

Let us try to sink ourselves completely into what we receive through colour from the rich and varied world around us. We must feel what is in colour if we wish to penetrate into its true nature, bringing insight into our feeling. We must question our feelings about what is living in the colour which surrounds us. To start with we must experiment, taking examples which are not too difficult to analyse but have some striking characteristic which can help us to reach the essentials.

Let us begin with the colour green, spreading it as a plain surface in a quite diagrammatic manner. If we now simply let our feelings respond to this colour, we can experience something in the green which needs no further definition. No one can doubt that we have the same experience from this colour as when we look at the plant-covered earth about us; we cannot help it, of course, because it is green. We must disregard everything else the plants mean to us and look only at their greenness.

We could very easily insert the most varied colours into our patches of green. We will, however, limit ourselves to three particular colours: into the first patch I place some red, in the second a kind of peach-blossom colour, and in the third patch, blue.[2] Now from your immediate impression of these three examples you will

agree that something quite different happens in each case. If I look at this red shape within the green, or the peach-blossom, or the blue, I have a quite definite feeling from each. The next step is to express what lies in these different feelings as our soul experiences them.

Abstract definitions can achieve very little; we must try to bring out the true character of our actual experience. Therefore let us try to enter imaginatively into the colours we have here. From the first example we may have the impression of a green countryside in which I have drawn red figures. It does not matter whether I give them red faces and skin, or red clothes. In this first example I have painted red figures; in the second, figures in peach-blossom colour (which is similar to the colour of the human skin); and in the third patch of green I have painted blue figures. We are not creating pictures but simply making a definite series of impressions.

Imagine you have the following scene before you: figures in red, or figures coloured like peach-blossom, or figures in blue walking over a green meadow—in all three, quite different impressions! Looking at the first you might say: the red figures in their green surroundings enliven the whole green meadow. The meadow becomes all the greener because of the presence of the red figures whilst the green becomes richer, more living. I should find it disturbing if these red figures were not painted as moving figures. It would feel wrong in any other way: I should want to say—it just cannot be like that. I have to make these red figures like lightning; they must be *moving*. Still red figures in a green meadow! They are disturbing in their stillness. They are moving because of their very redness. They bring something with them into the meadow which cannot possibly be kept still. We must experience a quite definite range of feelings if we are to gain any insight.

The second picture is entirely harmonious. The peach-blossom figures can stay there quite peacefully; they can stay there for ever. My feeling tells me that these peach-blossom

figures have no especial relationship with the meadow and do not affect it by making it seem greener; they are quite neutral. They can stand where they like without troubling me; they have no inner connection with the green meadow.[3]

Now let us look at the third example, blue figures in the green meadow. The green, surely, does not remain unchanged: the blue begins to dissipate the green meadow in which the figures stand. The meadow's greenness is paralysed; it is no longer green. Let us try to grasp imaginatively what is going on: blue figures (they could just as well be blue spirits) are wandering about in a green meadow—this then ceases to be green and takes on a bluish hue. The meadow itself becomes bluish and ceases to be green. And if these blue figures were to remain long in the green meadow it would all slip away from me. Then I find myself thinking that the blue figures are trying to carry off the meadow and dispose of it in some deep abyss. A green meadow just cannot stay as it is if there are blue figures in it; they take it up and make off with it.

This is how one can *experience* colour.

And we must be able to have colour *experience*, or we cannot grasp what the world of colour is at all. The imagination is a fine and beautiful instrument but we must experiment with it if we want to discover this for ourselves. We must ask what happens to a green meadow in which red figures move. Does it not become more vividly green, its greenness more intense, so that the green begins to burn? The red figures cause such activity in the green which surrounds them that they themselves can no longer stay still; they must run about. And if I want to paint in the right way I cannot paint people who stand still as red; I would have to paint them as if they were dancing in a ring. A ring of red figures dancing in a green meadow would appear quite natural.

On the other hand, figures the colour of the human skin could stand in the green meadow just like that for all eternity. They are quite neutral towards the green meadow; they remain just as they are without changing in the least—

quite different from the blue figures who make off with the
meadow taking its greenness from it.

In order to discuss our actual experience of colour, we
need comparisons. A crudely philistine approach will not
let us experience colour at all. We must make comparisons
but not the usual philistine kind of comparison to say, for
instance, that one billiard ball pushes another. (Stags push,
also bullocks and buffaloes, but not billiard balls in actual
fact.) We have to speak of "thrust" in physics because we
need the support of analogy in order to speak at all.

This makes it impossible to look into the world of colour
as it is. It is within that world we must seek the real nature
of colour.

Let us take a characteristic colour which we have already
looked at—the colour green which we enjoy so much in
summer time. We are quite used to seeing this as the colour
which belongs particularly to plants. There is no other
sphere in which we experience a colour so intimately bound
up with the inner nature of an object as green is with the
plant. If an animal happens to be green we do not feel it
must be this colour and no other, but we have an underlying
feeling that it could be some different hue. But with plants
we have the impression that green belongs to the plant as
something peculiarly its own. We can now try through the
green of the plant to penetrate the objective nature of colour
instead of remaining as hitherto within its subjective aspects.

What is the plant which can reveal the colour green to us
in such a special way?

From spiritual science you know that the plant owes its
existence to the fact that, besides its physical body, it has
an etheric body.[4] It is the etheric body which is the source
of life in the plant. But the etheric body is not green. What
makes the plant green is to be found in its physical body;
although green belongs to the plant in a most intimate way
it is not the essential nature of the plant—that lies in the
etheric body. If the plant had no etheric body it would be

a mineral and it is the mineral nature of the plant that appears as green. The etheric body is quite a different colour although it does reveal itself in the plant through the green of the mineral element. If we study the green of the plant in relation to the etheric body we have on one side the true nature of the plant which lives in the etheric world and on the other the green which has been drawn off and separated from the plant. But in taking green from the plant it is just as if we had made a copy of something. What has been abstracted from the etheric in green is really only a picture (or image) of the plant; this image, so characteristic of the plant, can only be green.[5] In green we have the image of the plant. If green is regarded as the essential plant colour then it must also be regarded as a picture (or image) of the plant; in green we see the especial character of the plant as image.

This is absolutely essential. In the portrait gallery of an old castle it is obvious that only portraits of the ancestors hang there and not the ancestors themselves. Usually the ancestors themselves aren't there, only their portraits! In the same way, the essential plant is no more in the green than the ancestors are actually present in their portraits. When we look at green we have no more than the image of the plant. Now think once more how green is peculiar to the plant and remember how the plant is above all the most characteristic form of life. The animal possesses a soul; man has soul and spirit. The mineral is without life. Life is the particular characteristic of the plant. The animal has, in addition, a soul. (The mineral kingdom is also without soul.) Man has, besides these qualities, a spirit. We cannot say of man, animal or mineral that life is the essential quality; in each case it is something else. With the plant, *life* is its essential characteristic—the colour green is the *image* of this life. We can therefore say quite objectively:

Green represents the lifeless image of the living.

Proceeding inductively—as the learned should—we have now arrived at the point where an objective description of

the colour green is possible. Just as the photograph can be described as a picture of someone or something, so green can be described as the lifeless image of that which is living. I have passed from mere reflection on the subjective impression to the realisation that green is the lifeless image of the living.

Now let us take another colour, peach-blossom. To be more precise, I should rather speak of the colour of the human skin which naturally differs from one person to another—but this is really what I mean when I speak of peach-blossom: the human colour or the colour of the human skin. Let us now try to understand its essential nature. Usually we look at it only from outside: we look at a man and see the colour of his skin only from outside. Can we become aware of it, know it from within, as we have tried to do with the green of the plant? We can, if we do it in the following way.

If a man really tries to become aware that he is a being of soul and thinks of this inner life of soul as being present within his physical form, then he will also realise that the soul must be visible to some extent in the physical form. His nature is revealed by the way the soul flows into his physical form in the colour of his skin. What this means can best be realised by looking at a man whose soul is no longer fully present in his skin, whose outer form is no longer ensouled. What happens to such a man? He turns green. Life is still there, but he turns green. We speak sometimes of "green" people and we know the peculiar green of the complexion when the soul is no longer fully present. The effect shows clearly in the human complexion. On the other hand, the more a man's complexion takes on a particularly ruddy hue the more we are aware of how he lives in it. If we observe the temperament of a "green" person and one with a really fresh complexion it becomes evident how the soul lives in the actual colour of the skin. Each man's experience of himself shines forth in the very colour of his skin. So we can say that the colour which appears in the human com-

plexion is in fact an image of the soul. Of all the varied colours in the world around us peach-blossom is the colour we would select as being nearest to that of the human skin. (In painting we can only imitate the colour of human skin by various artistic devices.)

Now, whilst the colour of the human being is indeed the image of the soul, it is quite clearly not the soul itself. It is the living image of the soul. The soul, experiencing itself, is revealed in the colour of the human skin. And this colour is not lifeless like the green of the plant. Only when his soul withdraws does a person turn green; then he can become a corpse. But in this colour we have something that is alive:

Peach-blossom represents the living image of the soul.

We have now considered two colours; in both cases they have been "images". We have endeavoured to understand the objective nature of colour, not merely to take the subjective impression and invent a theory of wave motion to explain it which is then imagined to be objective. It would be quite absurd to divorce human life from the colour of the human skin. It is quite a different physical experience to have pink cheeks or a greenish pallor. A definite inner existence is revealed through the colour.

Let us now take a third colour, blue. It is impossible to find anything of which we can say that blue is characteristic in the way that green is characteristic of the plant; nor could we speak of blue as we could of peach-blossom and the human complexion. Amongst animals there is no single colour which is as characteristic of their nature as the colour of his complexion is of man, or green is of the plant. With blue we cannot start, as we have done so far, from natural phenomena.

If we want to continue our exploration of the nature of colour we should leave blue aside for the moment, and turn to the lighter colours. If we take the colour known as white we shall find that we shall progress more quickly and easily. White cannot be said, in the first place, to be the

characteristic colour of any being in the outer world. We could, of course, turn to the mineral kingdom, but it would be better to look in quite another direction to form an objective idea of the colour white. Let us imagine we have some white in front of us and light is allowed to play upon it, illuminating it; at once we feel a certain kinship between the white and the light. At first this is merely an impression, but it becomes more than an impression the moment we turn to the sun itself. For the sun has a certain whiteness in its light and is the source from which all natural illumination on earth is derived. But neither what we see as the sun, nor as white—with its inner kinship to light—appear in the same way as external colours do. External colours appear on objects. The whiteness of the sun, which represents light to us, does not appear directly on objects. Later on we will consider the kind of colour we may call the white of paper or chalk, but that will mean making rather a detour.

First of all, in order to understand white we should let ourselves be led by white to the light as such. In order to strengthen this feeling we need only remember that the opposite of white is black. We have no doubt that black is darkness; we can very easily identify white with brightness, with the light as such. In short, we find an inner connection between light and white when we allow our feelings to speak to us. (We will investigate this further in the next few days.)

If we reflect on the nature of light—and are not tempted to cling to the Newtonian fallacy but observe things without prejudice—we shall say: there is a special connection between white, appearing as colour, and light. (We will at first leave true white on one side.)

We know of light as such, however, in a different way to the other colours. Do we really perceive light? We would not see colour at all if we were not in an illumined space. Light makes colour visible but we cannot say that we perceive light just as we do colour. Light is certainly present in the space in which we see colour; it is the nature of light

to make colour visible. But we do not see light as we do red, yellow or blue. Wherever it is bright there is light, but we do not see the light. Light must fall on something if we are to perceive it; it must be caught and reflected. Colour exists on the surface of objects, but we cannot say that light is fixed to anything; it is always in movement.

But, when we wake in the morning and the light streams around and through us, we become inwardly aware of ourselves; we feel an inner kinship between the light and our own essential being. At night, if we wake up in dense darkness we feel we cannot reach our real being; we have returned to some extent to ourselves but under such conditions we do not feel in our true element. And we know, too, that what we receive from the light is a "coming to ourselves". (There is no contradiction in the fact that the blind are without this experience; the point is that their organism is designed for it.)

We have the same relationship to light that our "I" has to the world; yet not quite the same, since we cannot say that because the light fills us we gain our "I". Nevertheless, for us to gain this "I", light is essential if we are beings with sight.

What underlies this fact? In light, which we have said is represented by white (we have still to learn the inner connection between the two), we find what really fills us with spirit, connects us with our own spirit. There is a definite connection between the "I", our spiritual being, and this experience of the light shining through us. If we grasp this feeling—and all that lives in light and colour must first be grasped as feeling—we may say: there is a distinction between light and that which appears as spirit in the "I". Nevertheless the light gives us something of our own spirit. In such a way we shall be able, through the light, to experience how the "I" becomes inwardly aware of itself by means of the light.

To sum up, we can say that the "I" is spiritual but it must experience itself within the soul; this it does when it

feels itself filled with light. We may express this in the formula:

White or light represents the soul's image of the spirit.

Let us now move on to black or darkness. It is easy enough to see why I should deal with white and brightness and light at the same time as the relationship between darkness and black. Let us now try to grasp something of their nature, too.

Certainly we can easily find something in nature which is just as characteristically black as the plant is green. We need only look at carbon. If we remember that carbon can also become quite clear and transparent—indeed, a diamond—we will be able to understand this connection of blackness with carbon most clearly. For black is so characteristic of carbon that, were it not black but white and transparent, it would be a diamond. Black is so integral a part of carbon, that the latter really owes its whole existence to the blackness. Carbon really finds its own nature in the blackness, the darkness, in which it appears. Just as the plant has its image in green, so does carbon have its image in black.

Now submerge yourself in black; you are completely surrounded by black—in this black darkness a physical being can do nothing. Life is driven out of the plant when it becomes carbon. Black shows itself alien to life, hostile to life; when plants are carbonised they turn black. Life, then, can do nothing in blackness. And the soul? Our soul life deserts us when this awful blackness is within us. But the spirit flourishes; the spirit can penetrate the blackness and assert itself within it. You can try to learn more about this through the art of black and white, using light and shade on your paper (we will return to this aspect later). If you use black on a white surface you introduce spirit into it; the effect of a black stroke, of an area of black, is to spiritualise the white. You can bring spirit into the black, but this is all that can be brought into it. Now we have this formula:

Black represents the spiritual image of the lifeless.

It is quite natural that these formulae have to be evolved out of pure feeling. You must now try to penetrate still deeper into what they express and you will see that they really contain a great deal:

Green represents the lifeless image of the living
Peach-blossom represents the living image of the soul
White or light represents the soul's image of the spirit
Black represents the spiritual image of the lifeless

In each colour we have discovered an image of one kind or another, but the colour itself is never the reality, only an image. In the first we have the image of the living, then of the soul, the spirit, and the lifeless.

If we now arrange this scheme in a circle (see diagram), we arrive at something of real significance in studying the objective nature of colour. From this circle we can see the relationships between certain fundamental colours: black,

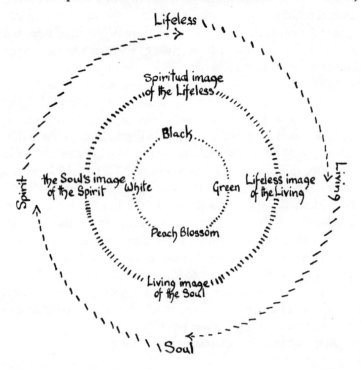

green, peach-blossom, and white. The adjective characterising each colour is found by moving back to the preceding point on the circle: black is the spiritual image of the lifeless, green the lifeless image of the living, peach-blossom the living image of the soul, and white the soul's image of the spirit.

By taking the kingdoms of nature in this way, I am able to ascend stage by stage from the lifeless to the living, then to the realm of ensouled beings and finally to beings of spirit. In a similar way I can go from black to green, to peach-blossom and to white. Just as I can ascend from the lifeless through the living to beings of soul and spirit, so the world around me appears in its images as I go from black to green, to peach-blossom, and to white. Just as Constantine, Ferdinand, Felix, and so on, are real people and I can follow them down their ancestral line so can I look at their portraits in turn and see the "images" of their line of ancestry. The world is there before me with its minerals, plants, animals and its spiritual kingdom—in so far as man is taken as the spiritual. As I ascend through these realities nature reveals their images to me. They are reflections cast by nature. The coloured world is not reality, even in nature itself it is only image. The image of the lifeless is black; of the living, green. The image of the soul is peach-blossom; and of the spirit, white.

By these means we are led to the objective nature of colour. We had to establish this today so that we can penetrate further into the true nature and being of colour. For it does not help in the least to say that colour is a subjective impression—it is of no significance at all to the colour. To green it is quite immaterial whether we go and stare at it; but it is far from immaterial that when the living clothes itself in its own characteristic colour this appears outwardly as green—so long as it is not tinged by the mineral nor coloured in the flower. This is a quite objective matter. Whether we stare or not is entirely subjective. But the fact that the living when it appears as such should be imaged in green—that is something quite objective.

LUSTRE AND IMAGE

My dear Friends,

Yesterday we tried to understand the nature of colour from one particular aspect which led us to the four colours, black, green, peach-blossom and white. We found that we could describe them as already present in the world with the character of images. We saw how this image character appears when one form of existence is taken up in another; how, for instance, the living must be taken up in the lifeless for the image of the living, green, to appear.

Today I would like to take yesterday's experience a stage further. I shall do this by making a distinction between that which gives and that which receives, between that element in which the image is formed and that which causes the image. Then I shall be able to develop the following structure for you.

I will start by distinguishing the shadow-thrower from the illuminant—you will understand these expressions if you recall all that we experienced yesterday. If it is the spirit which throws the shadow, the spirit receives what is thrown upon it, and if it is the lifeless which illumines (this is apparently a contradiction, but in reality it is not so) then black is formed, as we saw, in the spirit as the image of the lifeless (see diagram p. 22). If the lifeless is the shadow-thrower and the living is what illumines then green will appear, as in the plant. If the living is the shadow-thrower and the soul-nature is the illuminant, then peach-blossom is formed as the image. If the soul throws the shadow and the spirit is what illumines then white will appear as image.

Shadow-thrower	Illuminant	Image
the spirit	the lifeless	black
the lifeless	the living	green

| the living | the soul | peach-blossom |
| the soul | the spirit | white |

We have then four colours with this image character. We may say that in each there is one element which throws a shadow and another that illumines; the two together make a picture (or image). We have found four colours (black and white must be counted as colours), four colours with an image character: black, green, peach-blossom, and white.[6]

There are, of course, other colours and we need to discover their essential nature, too. We will try to do this once again through a certain sensitivity to the impressions we receive and not through abstract concepts. Then you will see that it is possible to attain a sensitive understanding by dwelling on the following.

Imagine a placid white. Into this placid white we introduce two different colours from opposite sides; from one side yellow, from the other blue . . . You must imagine this placid white—it can be a plain, white surface—into which we let yellow play from one side and from the other blue: we then obtain green.[7]

We must visualise exactly what happens. We take a placid white into which we let yellow and blue play from either side and these give us the green which we have already discovered from quite another point of view.

Now, if we enter livingly into the way in which colours come into being, we cannot look for the nature of peach-blossom as we looked for green. We must try to find it in quite another way—in the following manner. Imagine that I paint black here, underneath it some white, here some more black, underneath again white, and so on, black, white . . . You must imagine that the black and white are not still but in movement, weaving into one another. This is the opposite of the first example; then we had a placid white into which we let yellow and blue play from left and right in a continuous process. Now I take black and white—I cannot, of course, paint it, so you must imagine them weaving into

one another—and just as I let yellow and blue play in from left and right so now I let this interweaving movement of black and white be shone through, irradiated by red. If I were to choose the right shade then, through this interplay of black and white into which I let the red shine, I would get peach-blossom.[8]

Notice that we must make use of quite a different method. In one case we take a placid white, one of our series of image colours, which we obliterate by letting two other new colours play into it. In the other case we take two of the colours we already have, black and white, and set them in movement; then we take another new colour, red, and let it shine through the black and white. The same thing will strike you if you observe the living. Green you will find in nature; but peach-blossom (yesterday I indicated in what sense I meant) only in the healthy human being whose soul is present within his physical organism. I remarked then that it is not very easy to reproduce this colour; it can only be done if black and white are shown in movement with red shining through them. A process must really be created. This process is also present in the human organism which is never at rest.[9] It is always in movement and through this arises the colour we are speaking of. When we paint, however, we can only obtain this colour in a roundabout way. Indeed, for this reason most portraits are really no more than masks since the real, living colour present in the complexion can only be suggested by various approximations. It is, however, possible to achieve the colour by a continual interweaving of black and white which is shone through, irradiated, by red.

I have here indicated from the essential nature of the case a certain distinction in relation to colour. I have shown how we can make use of two of these image colours; how in one instance we can take white by itself at rest and play two new colours into it in order to produce another image colour—green. Again, taking two image colours, black and white, we can set them weaving in and out of one another and illumine them with a further colour in order to obtain

the second image colour, peach-blossom. We have obtained green and peach-blossom in quite different ways. In one instance we needed two luminous colours, yellow and blue; in the other, one luminous colour, red.

We should now be able to elaborate further what we discovered yesterday about the nature of colour if we consider another aspect. We can say the following: green, by its nature, allows us to confine it within definite limits. To some extent, green allows itself to be circumscribed; we do not find it objectionable if we spread green over a surface and give it definite boundaries. But just think of doing this with peach-blossom! Peach-blossom confined within boundaries— this would not be at all true to artistic feeling. Peach-blossom can really only be handled as a kind of mood, where any thought of definite boundaries is out of the question This is a real experience for anyone who has a feeling for colour. Think, for instance, of something green—perhaps a card-table with its green covering. Because a game is a limited, pedantic activity, completely philistine, we can quite easily associate it with a room in which there are green tables. An invitation to play cards at lilac-coloured tables would be enough to make one want to run away! On the other hand, a lilac-coloured room, a room decorated entirely in lilac, would lend itself very well to mystical conversation, in the best and worst sense! Considered in this way colours do not work in an anti-moral fashion but are amoral. Thus we discover that it follows from the very nature of the colour, from its inner character, that green may be confined within definite limits whilst lilac or peach-blossom, the human skin colour, will always disperse into something indefinite.

We will now try to understand the colours we omitted yesterday from a similar standpoint. Let us take yellow in its essential, inner quality and attempt to spread it on a surface. You will see that a yellow surface with definite boundaries is a repulsive thing; it is quite unbearable to artistic feeling. The soul cannot bear a yellow surface which

is limited. We must make yellow paler at the edges, then paler still; in short the yellow must be full in the centre, shining out into a still paler yellow. If we are to experience its inner nature we cannot imagine yellow in any other way.

Yellow must shine outwards.

It must be deeper in the centre and radiate; it must spread out, becoming less concentrated and weaker all the time. That is what I might call the secret of yellow. It is like mocking the very nature of yellow to give it a boundary, which is something imposed by man. Yellow is gagged when it is confined for it does not want to be bounded but to radiate in all directions. We shall see a case in a moment where yellow does consent to be bounded but it will be evident from the example itself how much it goes against the nature of yellow to be defined. It *wants* to radiate.

Now, in contrast, let us turn to blue. Imagine a surface with blue spread evenly over it. This is something which leads us away from the purely human. When Fra Angelico painted his even, blue surfaces he summoned, as it were, something divine into the earthly world. He felt he could paint an even blue only when he wished to bring something divine into the earthly world. He would never have allowed himself to do this for the purely human situation; for blue, because of its very nature and character, will not readily submit to being a flat, even surface. It needs the divine to intervene for blue to be spread evenly.

Blue by its inner nature demands the exact opposite of yellow. It must shine in from the circumference. It demands to be at its fullest at the edges and to be at its least intense towards the inside. Blue is in its true element if we make it fuller on the outside and weaker in the middle. This is what makes it so different from yellow. Yellow wants to be strongest in the centre, and then to pale off. Blue dams itself up at the edges, flowing together into a wave which dams up around a lighter blue. Then it reveals its essential nature.

Blue shines inwards.

Thus we return every time to the feelings and longings which arise in the soul through its experience of colour. If they are to be fulfilled and the painter really responds to them—if he is to paint according to the demands of the colour itself, then he must begin to think: now I've dipped my brush in the green, now I must be a bit of a philistine and give the green a sharp outline—or—now I'm painting yellow: I must let it radiate, I must imagine myself spirit, shining spirit. Or again, when painting with blue: now I draw into my innermost self and form a kind of enclosure around myself—so I must paint my blue by giving it a kind of crust. Then he will be living in his colour and will paint his picture in tune with what the soul experiences when it is absorbed in the essential quality of colour. Of course, as soon as we begin to create artistically, factors play in which modify the whole situation.

Now I will draw three circles for you which I will fill with colour; I could, of course, use other figures or shapes. To begin with I can, for instance, make the yellow quite small in area, then spread it out, letting it shine out in the small area differently than in the surrounding area. Yellow must always radiate over something; but blue must always be handled so that it can withdraw, as it were, into itself.

Red, however, might be said to be the balance between these two.[10] We can accept red as a surface without difficulty. We can most readily understand this if we see how different it is from peach-blossom in which it appears, as we have seen as an illuminant. Place the two colours next to one another, peach-blossom and red. If the red is really allowed to make its own impression, how does it affect you? It will make you want to say:

Red affects me through its stillness.[11]

It is not so with peach-blossom, which wants to dissolve and spread out. A fine distinction can be drawn between red and peach-blossom. Peach-blossom tends to disperse

and become thinner and thinner until it has evaporated altogether. Red, however, is enduring and makes its effect as a surface; it does not want to radiate nor to become piled up and encrusted, but to remain as still redness. It does not want to evaporate; it asserts itself. Lilac, peach-blossom or flesh-colour do not really assert themselves but always tend to assume new forms because they want to vanish. That is the difference between these two colours—peach-blossom, which we have already dealt with, and red, which is new to us.

We have now brought these three colours together: yellow, blue and red. Yesterday we grouped four other colours together: black, green, peach-blossom and white. Today we have tried to feel our way into yellow, blue and red and how they play into the other colours. We have let red play into black and white in movement and we have let yellow and blue play into placid white. In each case our inner experience will easily allow us to discern the difference. We could not make such distinctions between the colours we took yesterday as we have now made between yellow, blue and red. We found with peach-blossom that we had to let black and white weave in and out of each other with each maintaining its own identity. We cannot make more of them than that; black and white are image colours which can weave one into another and must be left at that.

Peach-blossom, too, we must leave alone; it disappears of its own accord, we cannot do anything with it and are powerless to control its fleeting quality. It can do nothing by itself; it is its nature to disappear. Green limits itself, that is *its* nature. But peach-blossom has no desire to be differentiated, nor to be uniform like red; it does not want to be differentiated but would much rather lose itself and disappear altogether. Just imagine peach-blossom with lumps in it! It would be dreadful. It would promptly dissolve the lumps, for it strives towards sameness, towards an evenness of mood. It is quite another matter if one green is placed upon another, for green wants to be spread uniformly and given

definite limits. We cannot imagine a radiant green. We can well imagine a shining star but not a shining tree-frog! It would be a contradiction for a tree-frog to shine. Well— that is also the case with peach-blossom and green.

If black and white are to be brought together at all we must let them weave into one another as images, although as images in movement. But it is different with the three colours we have found today.

We have seen that yellow, through its very nature, wants to grow paler and paler towards the edges, that it wants to radiate. Blue wants to dam itself up and red to be uniform, not within boundaries but acting as a uniform, still redness. Rather we should say that it wants neither to radiate nor to be dammed up but to be effective all over; it wants to hold the balance between radiating and being dammed up, between flowing out and damming itself up.

So you see that there is a fundamental distinction between these three colours and those which are either innately still or in movement—still like green or in movement like peach-blossom, or isolated like black and white. When we group these colours together it must be as images. We have found that the inner activity, the inner movement of red, yellow and blue is distinct from the movement of peach-blossom. Peach-blossom tends to dissolve—this is not an inner movement—it wants to evaporate. Red, it is true, is still; it is movement which has come to rest. But when we look at red we cannot concentrate our gaze on one point—we feel that red needs to be a surface, an even surface, but one which is not bounded. We have seen how differently yellow and blue are each constituted. Red, yellow and blue are quite different from black, white, green and peach-blossom. In contrast to the colours which have an image quality, red, yellow and blue have quite another character and if you recall what I have said about them you will be prepared for the term which I am now going to use to characterise the difference. I have called black, white, green and

peach-blossom: *picture or image colours*. I will call yellow, red and blue: "lustres"—*lustre colours*.[12] Black, white, green, peach-blossom are formed as images but objects actually shine with yellow, blue and red. As they display their surfaces they gleam and glisten.

Here lies the essential nature of, and principal differentiation within, the world of colour:

Black, white, green and peach-blossom have an image-character—they are "pictures" of something.
Yellow, blue and red have a lustre-character—something shines from them.

Yellow, blue and red: these are the outward aspects of an inner reality. Green, peach-blossom, black and white are never more than reflected images, always somewhat shadowy.

So we can say, speaking in the widest sense, that black, green, peach-blossom and white are fundamentally shadow-colours. The shadow of the spirit in the soul is white. The shadow of the lifeless on the spirit is black. The shadow of the living on the lifeless is green. The shadow of the soul on the living is peach-blossom. Shadow and image are closely related to each other.

In blue, red and yellow, however, there is something luminous, not shadowy; something that declares its inner quality outwardly. So on one hand we have images or shadows and on the other we have in red, blue and yellow variations of something that shines.[13] Therefore I call them lustres. Objects glisten and gleam in certain ways. The essential nature of these colours lies in their radiant quality: yellow radiating outwards, blue radiating inwards, towards itself, and red the balance between them, radiating evenly. When this evenly shining colour illumines white and black which are in movement, peach-blossom arises. When yellow plays from one side and blue from the other on to a quiescent white, green arises.

Here we have things which are thrown together quite

chaotically in physics (and this includes everything said about colour today). The spectrum scale is simply noted down: red, orange, yellow, green, blue, indigo, violet: there is no mention of what plays within it. Let us run along the scale. Starting with the lustre red, the lustre quality gradually diminishes until we reach an image or shadow in green. Then we come to a lustre of an opposite kind to the first, to blue, the lustre which is dammed up. At this point we must leave the physical realm and the usual colour spectrum entirely in order to reach what can only be represented in movement: the peach-blossom colour which arises when white and black are shone through, irradiated, by red.

If you take the usual diagram found in physics then all you have is . . . red, orange, yellow, green, blue, indigo, violet . . . Now if I do not show it as it appears on the physical plane but as it is in the next highest world, I would have to bend the warm and cold sides of the spectrum so that it is drawn like this—red, orange, yellow, green, blue, indigo, violet. If I were to bend the band of colour which was stretched out in a line back upon itself I would have my peach-blossom colour up here at the top. I have come back again to an image colour. Image colour I, above, and II, below: lustre III, left, and IV, right. Now only the other two colours, black and white, remain hidden. If I bring the white up here (from below up) it would stay in the green, but then the black comes down to meet it from above and they begin to ripple into each other creating, with the red lustre, peach-blossom. I have to imagine white and black overlapping and weaving into each other. In this way I obtain a complex arrangement of colours which, however, reveals more of the nature of colour than you will find in books on physics.[14]

We have spoken of lustre colour—but lustre means that something shines. What is it, then, that shines? With yellow you need consider only the following (but you must do it with feeling and not with abstract understanding): I cannot

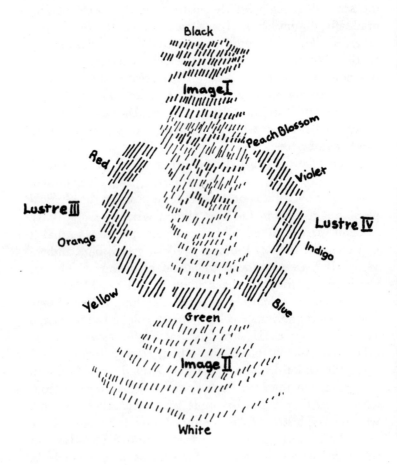

help being so moved by the impression that yellow makes on me that it lives on within me. Think how joyful yellow makes everyone. And being joyful after all means being filled with a greater vitality of soul. Through yellow we become more attuned to our own "I", we are, in other words, filled with spirit. If you take yellow in its original stage, fading outwards, and think of it shining within you because it is a lustre colour, shining into you as spirit, you will have to say: yellow is the lustre of the spirit. Blue, gathering itself together inwardly, dammed up, enclosed within itself, is the lustre of the soul. Red, filling space evenly, is the lustre of the living.

Yellow is the lustre of the spirit.
Blue is the lustre of the soul.
Red is the lustre of the living.

Green is the image of the living and red the lustre of the living. You can see this very easily by looking at a fairly strong red on a white surface and then looking away quickly. You will see a green after-image, the same surface will appear as a green after-image. The red shines into you and forms within you its own image.

But what is the image of the living, inwardly? You must destroy the life to have the image.[15] The image of the living is green. It is little wonder that the lustre red when it shines into you forms green as its image.

So we see that there are two quite different kinds of colour—the active and the passive. There are the colours that shine, although with certain inner differences of quality; there are others which are quiescent images. This is something which has its analogy in the cosmos. In the cosmos we have the contrast between the motionless star-pictures of the zodiac and the differentiating activity of the planets. It is only a comparison but one that is inwardly founded in fact.

We can say that black, white, green and peach-blossom have a quiescent effect. Even when one colour flows into another in movement, as black and white in peach-blossom, it still remains inwardly peaceful. In the three colours of

red, yellow and blue there is inner movement, a planetary quality. Something of the nature of the fixed stars is present in black, white, peach-blossom and green; something of the planets lives in yellow, red and blue. Yellow, red and blue tinge the other colours. White is tinged by yellow and blue to green. White and black are tinged, when red shines into them, to peach-blossom.

Here we have a definite colour-cosmos; we see the world as interweaving colour; we must go to the colours themselves in order to understand the laws that govern them. We must not be diverted into other paths but must keep to colour itself. When we have a proper grasp of colour we will see in the colours themselves what their mutual relationships are and what produces their luminous, shining quality or their shadowy, picture nature.

Think what this signifies for art. The artist knows that when he handles yellow, blue and red he must induce in his picture something that expresses an inwardly dynamic quality which itself gives character. If he is working with peach-blossom and green on black and white then he knows that an image quality is already present in the colour. Such a science of colour is so inwardly living that it can pass immediately from the soul's experience into art.

If you grasp the nature of colour in such a way that the colours themselves reveal their qualities; if you realise that yellow needs to appear deeper at the centre and fade away towards the edges because that is its nature—if you then fix yellow by painting it as an even surface, you will need to do something with it. What should this be? Something must be put into the yellow which deprives it of its original character, its own will. The yellow must be imbued with weight. When yellow is given weight it becomes the colour of gold. In doing this the yellowness is taken out of yellow; although remaining to some extent yellow, you have deprived it of its true nature. If you paint a picture with a gold ground it needs to be spread evenly over the surface; you have, however, given the yellow weight, inner weight.

You have taken its own will from it and fixed it down.

The painters of earlier times, who had a natural feeling for such things, sensed the lustre of the spirit in yellow. In yellow they looked up to the spirit, to the lustre of the spirit. But they wanted to give earthly expression to the spirit. They had to give yellow weight. When, like Cimabue, they painted a gold ground, they gave the spirit a dwelling on earth; they realised the heavenly in their pictures. The figures could stand out from the gold ground, growing out of it as creations of the spirit. In all these things there is an inner order and law. From this you will see that if we handle yellow according to its inherent nature, as colour it becomes stronger in the centre and disperses away from this. If it is to become fixed as an evenly covered surface then it must be mineralised. So we arrive at the conception of mineralised colour, of colour fixed in matter, about which we shall speak further tomorrow.

But colours must first of all be grasped in their full mobility before they can be understood as an actual physical quality belonging to external objects. Tomorrow we shall turn to this aspect, which is the only one associated with colour by ordinary people (and extraordinary ones for that matter!). For colour is considered only as it appears on solid objects and it is quite impossible from this to gain an understanding of it in its mobility.

The physical spectrum stretches endlessly from left to right, without limit. But in the spirit and soul world everything is linked together. Here we must link the ends of the spectrum together. We must train ourselves to see not merely peach-blossom colour, but the mobility of the colour of the human complexion. If we so train ourselves that this colour does not merely indicate what is human but is something in which we live, we shall become aware how the soul dwells in the physical body as the colour of the human complexion. This is the entry, the door, that leads into the spiritual world. Colour descends into the surfaces of physical objects but it also raises us from the purely material and leads us to the spiritual.

COLOUR IN MATTER
PAINTING OUT OF COLOUR

My dear Friends,

In the realm of colour we have made a distinction between those colours, black, white, green and peach-blossom, which we recognise from their qualities as image, and those colours which I have described as having a lustre quality—blue, yellow and red. We have seen how these have a kind of inner, individual will by virtue of their shining, gleaming quality. As you know, we can perceive colour in the so-called spectrum colours, in the rainbow where we see colour as colour and also in the colour of material objects. And when we practise the art of painting, which is the art of colour, we must of course use materials for our paints and be aware of their properties, how to mix them and so on. Here we come upon a significant question which is really left unanswered by the customary knowledge of the time, namely: how is colour, which we have learnt to know as constantly in movement, whether image or lustre, related to matter and material objects? What makes matter appear coloured?

Anyone who has looked into Goethe's *Theory of Colour* will probably know that he never really dealt with this question out of a certain intellectual honesty because he realised that with the means at his disposal he could not get to the heart of the problem: how is colour attached to solid matter? Yet this question is highly relevant to art, and painting. For painting is, to all appearance, concerned with just this phenomenon. We apply the colour and try to evoke an impression with it. So it is at this point, when we want to apply our investigations into the nature of colour to the art of painting, that we become interested in the appearance of colour in matter.

Since physicists have in recent times regarded the theory

of colour as a part of optics, we find explanations of the nature of colour in material objects worthy of recent physics. We find, for example, the characteristic explanation of the question: why is an object red? It is red because it absorbs all the other colours and reflects only red. This is an explanation characteristic of recent physics for it is based more or less on the kind of logic which says: why is a man stupid? Fundamentally he is stupid because he has absorbed a great deal of cleverness and radiates only stupidity! If one turns this logical principle, so common in colour theory, to the rest of life you see what interesting results occur!

As we have already remarked, Goethe was more honest about this question. He followed the problem as far as the means at his disposal allowed. Then he came to a halt, as it were, in face of the question: how does matter become coloured?

You will recall how we first came upon the image character of the first four colours we dealt with. We saw how it was a question of one form of existence producing its shadow or image in another. We saw how green arises when the living appears as image in the lifeless, and then how peach-blossom colour arises when the soul appears as image in the living. We also saw how white arises when the spiritual forms its image in the soul and, finally, how black arises when the lifeless forms its image in the spiritual. There we have all the colours which have the character of image; the rest have the character of lustre. In the external world, green is the most clearly visible expression of this image character. Black and white are in a certain sense borderline cases and for this reason are not generally considered by many to be colours. Peach-blossom, we have seen, is really only to be grasped in movement. Thus in green the image-character is most typically portrayed and with it we have the colour which is really attached to the external world, in particular to the plant kingdom. In the plant kingdom, therefore, the origin of "fixed" colour as image really becomes apparent. It is now perhaps a question of discovering in the green of plants

what is the true quality, the essential nature of green. In doing so we must go a good deal further with the problem than would normally be considered necessary today.

We know from *Occult Science*[16] that the plant kingdom was really formed during the previous metamorphosis of our present Earth; but we also know that at that time there was as yet no solid matter. In the plant kingdom, then, we have something which has been formed during the former metamorphosis of the Earth and was then transformed during its further evolution. The plants were formed in the fluid conditions of the Old Moon evolution when there was no solid matter. This fluid state was permeated with flowing colour. There was no need for it to be fixed to anything, or at least only to the surface. Only on the surface did the fluid element begin to solidify. So it would be possible to say, looking back to this earlier stage of evolution, that in the formation of the plant we are concerned with an essentially fluid condition in which green, as also colour generally, existed in flowing movement.

And it was only during the Earth period of evolution— as you can see from *Occult Science*—that the plants were able to take on a firm form and incorporate the mineral element. It became possible for the plant to have a definite and no longer fluctuating nature so that what we now describe as the plant appears for the first time during Earth-evolution. Only then could colour assume the character which we see in the plant today and appear as a fixed green.

Green is not the only colour usually seen in a plant which, as we know, in the course of its metamorphosis takes on other colours; it has yellow, blue or white flowers, or red flowers, or fruit, as in the melon for instance, which is transformed from green into yellow. Quite a superficial observation shows us what happens when the plant takes on a colour other than green. When this happens you can quite easily observe that the appearance of these other colours is connected with the sun, with direct sunlight. Just consider how plants hide themselves and curl up if they cannot hold up

their flowers to the sunlight. There is a connection, if only a superficial one, between the sun and certain parts of the plant not being coloured green. The sun, as it were, meta-morphoses the green; it encroaches upon the green and transforms it.

Having related the varied colours of the plant with a heavenly body, even if only superficially, it will not be a difficult matter to turn to the statements in *Occult Science* and to ask what its observations reveal about other possible connections between the colouring of plants and the stars.

Here we have to ask ourselves: what kind of heavenly body has the strongest effect on earth, working in an opposite way to the sun, to produce in the plant what the sunlight later metamorphoses, negates as it were, and transforms into other colours? What in fact causes green to arise within the plant kingdom?

We will be led to that heavenly body which appears as the polar opposite of the sun: the moon. Spiritual science can establish (I can only touch upon these things today) the connection between the green of the plant and the moon and also between the other colours and the sun by contrast-ing the properties of moonlight as opposed to sunlight, and especially by the way that moonlight works within sun-darkness. Thus in the plant we have an interplay of sun and moon influences. But at the same time we have an explana-tion of why green becomes an image and does not appear luminous in the plant as the other colours do. The other colours in the plant have a shining, lustre quality. If you observe the colours of flowers with the right kind of feeling you will see that they *shine* at you. Compare them with green: it is "fixed" to the plant. You will see here nothing else than a copy of what you perceive in the cosmos. Sun-light shines: moonlight is the image of the sunlight. In the same way the image of light, colour as image, appears in the green of the plant. It is through the sun that lustre colours appear in the plant; the image colour, as something "fixed", appears in green.

These things cannot be grasped by crude, physical ideas. They must be lifted into the realm of feeling and then grasped by a sensitivity permeated by spirit. What is understood in this way is transformed into art. Physics with its clumsy approach to the world of colour drives every artistic quality from its observations with the result that the artist has not the least idea what to make of its pronouncements concerning colour.

But when we look at a plant in such a way that we know that cosmic forces are at work and that sun and moon forces interplay to produce colour in the plant we have the basic elements for understanding how, with plants at least, colour is "fixed" in an object and becomes material. It is due to image, and not lustre, influences from the cosmos that colour becomes material. In the plant, green has become an image because the moon has been separated from the earth during the course of Earth-evolution. In the separation of moon and earth we must seek the real origin of green in the plant kingdom. The plant is no longer exposed to moon-forces coming from within the earth but receives its image character from the cosmos.

In our feelings we comprehend the reciprocal relationships brought about by cosmic influences in the plant. We can therefore appreciate the character of green and the other colours in the plant through our sensitivity and through an artistic feeling for the nature of colour. If you study the history of painting you may find it remarkable that the great painters of earlier periods painted people and human situations but rarely nature, at least so far as the plant kingdom is concerned. Of course a superficial explanation for this can be found easily enough; one can explain it by saying that people in earlier times were not used to observing nature and therefore did not paint it. This is a very superficial explanation but people are easily satisfied with such explanations.

Something very different lies behind this. Landscape

painting only arises when materialism and an intellectual outlook grip mankind and an abstract view of life increasingly dominates civilisation and culture. Landscape painting is really the product of the last three or four centuries; only since then have men acquired the cast of soul which makes them capable of painting landscape. Why?

Looking at the paintings of an earlier period one is struck by their distinctive character. Precisely because we have learnt to distinguish (we shall be discussing this in greater detail) between the image and lustre character of colour, we discover that no such distinction was made by early artists in their paintings. They did not recognise, as we found ourselves impelled to do yesterday, the inner will of the lustre colours. They were generally unconcerned that yellow required a dissolving circumference. They were only aware of it when they depicted a more spiritual element, not when they painted the everyday world. Nor had they any concern for what we demanded of blue; a little more so in the case of red. You can see this in certain pictures by Leonardo and others, Titian, for example. But in general we can say that the earlier painters did not make the distinction between image and lustre colours. Why? They stood in quite a different relationship to the world of colour; they experienced the lustre quality of colour as image and treated it as image in their paintings. But if one gives an image character to what appears in the world of colour as lustre, if one turns everything into image, one cannot paint landscapes which include plants.

Why not?

If you want to paint a landscape with plants which gives an effective impression of life, then you must paint the plants in their individual colours, including green, somewhat darker than they really are. You must make the green, or the reds or yellows of different plants, generally darker than they are. But then, having made the colour darker than it is and tied it down as image, you must veil the whole picture with a yellowish-white atmosphere; you must

envelope the whole in a yellowish-whitish light. Then you can really express the nature of the plant in the right manner. You must paint a luminous veil over the image, introducing a lustrous quality.

I must ask you now to look at the whole tendency of modern landscape painting from this point of view, how it has probed ever more deeply into the secret of painting vegetation. The living element cannot be expressed if one just paints plants as they appear outwardly. The image gives no impression of life; this only appears when you paint the plants darker than they are and then pour over them a shining glow of yellowish-white light. Because the old masters did not cultivate this glowing quality in their art, this painting of light-filled air, landscape was generally beyond their reach. It is interesting to note, especially towards the end of the nineteenth century, how artists attempted to master landscape by painting out of doors and in other ways. It can only be mastered when the individual colours of plants are painted darker and a gleaming veil of yellowish-white is then drawn over them. Of course this must be done in such a way as to meet the requirements of colour-composition. Then you will be able to paint—on canvas or any other surface—a real impression of life. It is a question of the right feeling, a feeling which leads one to paint with what floods shining from the cosmos and pours as lustre over the earth. Only in this way can you enter the secret of the living world of plants and of nature.

From this you will realise that everything which we seek to achieve in painting must be found in the nature of colour itself. What is the painter's medium in the last analysis? He has to have a surface, of canvas, paper or other material, on which to fix the picture he is creating. But if his subject, like the living plant, will not allow itself to be fixed pictorially then at least a lustrous, shining quality should be poured out over it.

We have not yet dealt with the variously coloured minerals,

the lifeless substances. With these particularly we will have
to gain our understanding through feeling. The realm of
colour cannot be conquered by intellect; it must be grasped
through feeling. But now we have to consider the question
when we paint something inorganic, such as a wall or other
lifeless object: is it really necessary to understand what we
paint in terms of colour itself? It must be so! Just consider
how some things are bearable and some are not. A black
table painted against a white surface is quite bearable, is it
not? But if I were to paint a blue table—just imagine a
painting of a room full of blue furniture—if you have any
artistic feeling you would find it unbearable. Equally
impossible is a picture of a room with yellow or red furniture.
You could paint a black table on a white background—it
would only be a drawing but it could be done. A colour can
only really be used on canvas or paper to depict something
inorganic or lifeless when it has already assumed an image
character. We are then lead to the question: what do the
colours black, white, green and peach-blossom bestow upon
lifeless objects? The colour itself should tell us what it is
possible to paint. And if we take colours which are already
images we can never render lifeless objects effectively; we
merely have the image—and the colour is already that.
We still cannot call forth the representation of a chair but
only the image of a chair, if we paint it merely in an image
colour.[17]

What then must we do? We must endeavour, when
painting something lifeless, to give the image the character
of a lustre. That is the point. We must give the colours which
have an image character (black, white, green and peach-
blossom) an inner luminosity—a lustre character. Then what
has been enlivened to lustre can then be combined with the
other lustres, blue, yellow and red. The image colours must
have their image character stripped off and be given a
lustre character; when painting the inorganic the painter
must always be aware that a certain source of light, a dull
source of light, lies within the things themselves. In a sense

he must think of his canvas or paper as such a source of light. He needs this shining light present in the surface on which he paints. When he paints anything lifeless and inorganic he must never forget that something like a source of light lies behind it and that the surface is in a way transparent and shines out at him.

We now arrive at that point in painting when we fix a colour to a surface and have to imbue it with the quality of reflected light, of something which shines back to us; otherwise we merely draw and do not paint. The recent development of mankind demands that we continually strive to create paintings out of colour itself. We must continually be attempting to penetrate the essential nature of colour of impelling an image colour to take on the character of a lustre, to become inwardly shining. Otherwise we shall not be able to create a painting of inanimate nature which will be bearable. If a wall is depicted in a painting it will not be a wall, but only the image of one, unless the colour is made inwardly luminous. We must make the colours shine inwardly: they will then, in a certain sense, become mineralised. For this reason it would be good to give up painting from the palette which leads merely to smearing colouring matter on to a surface and makes it impossible to evoke the inwardly shining quality in the right way. We should try to paint increasingly from pots of liquid paint with colour that is liquid and has a flowing, shining quality. Generally speaking, the introduction of the palette has brought an inartistic element into painting. The palette has brought a materialistic form of painting, a failure to understand the true nature of colour—for colour is never really absorbed by any material body but lives within it and emanates from it. Therefore, when I put my colours on to a surface I must make them shine inwardly.

You know that we have tried to evoke these light-forces in our building[18] by the use of plant-colours through which the inner quality of light may be most easily expressed. Minerals with their various colouring possess this inner

it somewhat darker and then spread the lustre over it: lustre-image.

If we paint animals or ensouled beings, however, we must paint the colour as image-lustre but without going so far as to make it completely image. This can be achieved by painting more lightly and transforming the image into lustre, although in doing so we introduce something that to some extent obscures its pure transparency. In this way we get an image-lustre effect.

If we now go on to what is endowed with spirit, to the human being, we must aspire to paint in pure image colour.

Mineral (lifeless)	Lustre
Plant (living)	Lustre-image
Animal (ensouled)	Image-lustre[19]
Man (spiritual)	Image

Painters working before the era of landscape painting painted in just that way; they worked in the pure image colour. Here we come to the unmixed image. This means that those colours which we have learnt to know as lustres must now be grasped as image colours. This is so because when we come to man we need in a sense to take the lustre quality from the colours and to treat them as images. Normally when we brush yellow over the surface of our picture we feel we must do so in a certain way. The yellow insists on being frayed out, as it were, and washed away at the edges; yellow will not have it otherwise. If we paint human beings, however, we find we can ignore the colour's real nature and transform it into image. When we change lustre into image in this way we approach the human and we need not worry about anything but the pure transparency of the medium when we paint human beings.

Above all one needs to develop a feeling for the change that takes place in a colour when it is transformed into image. Indeed the whole nature of colour, in so far as this is expressed in painting, becomes accessible if one develops

luminosity, as anyone with feeling for such things will recognise, and it is this which must be captured when we paint lifeless objects. When we paint out of the nature of colour and not merely by copying the outward form, we become aware of the mineral kingdom in its inner light-nature. How does the mineral become inwardly shining? If we take up a mineral, its colour is visible because we see it in sunlight. But sunlight is less active in this instance than it is with the plant. In the plant the sunlight conjures forth the other colours in addition to green. But with coloured minerals and lifeless objects generally it is the sunlight which makes the colours visible, otherwise we see no colour—just as in the dark all cats are either grey or black! But the source of the colour is, after all, within. Why? How does it get there? We are back once more to the problem from which we started out today.

When dealing with green in the plant I found it necessary to point to the exit of the moon as described in my *Occult Science*. But now I must indicate other events that have happened in the course of the evolution of the Earth.

If you follow what is said in *Occult Science* about the development of the Earth, you will find that the heavenly bodies which surround the earth and belong to its planetary system were once connected with the whole Earth; they were expelled in just the same way as the moon. This is, of course, connected with the nature of the sun; but speaking only of the Earth, we can regard it as one exodus. And this exodus of the other planets is connected with the intrinsic colouring of lifeless things. Solids have become coloured, could become coloured, because the earth was freed from those forces which were within it when it was united with the planets. These forces could then work upon the earth from outside evoking the inner power of the cosmos in the colours of minerals. This is, in fact, what the minerals received from what has left the earth and now acts from the cosmos. We see that the mystery is much more deeply hidden than it was with the green of the plant. But just because it is hidden

we are enabled to penetrate more deeply into its nature, not only into the life of the plants but right into the lifeless minerals. So in our consideration of the colouring of solid matter we come (I can only briefly mention it here) to something not taken into account at all by present day physics. We are led to cosmic effects. We cannot understand the colouring of lifeless objects at all if we do not know its connection with what the earth has retained as inner forces through the departure of the other planets from it.

We will have to explain how one mineral or another may be red, for instance, because of the interaction of the earth and one of the planets, say Mars or Mercury; or how some may be a yellow colour because of the interaction of the earth and Jupiter or Venus, and so on. The colours of minerals will always be a riddle so long as the connection between the earth and what lies outside it in the cosmos is not understood.

When we approach the living plant we must not forget how sunlight and moonlight bestow on it the colours which shine from it as lustre and the green which becomes "fixed" to the surface. But if we wish to understand what shines out from the inner nature of material objects and how the once fluctuating colours of the spectrum have now become set within solid bodies, we must remind ourselves that what is out in the cosmos today was once within the earth and is the origin of everything on earth which has a fluctuating quality, even if this is to some extent weighed down. We must look outside the earth for the cause of what lies hidden under the mineral's surface; that is the essential thing. What is found on the surface of the earth is more readily explicable in earthly terms than that which lies beneath its surface. What lies under the surface within the earth, within solid matter must be explained by what is outside the earth. Thus the mineral elements of the earth gleam in colours which they have held back from what has left the earth with the planets and these colours remain

under the influence of the corresponding planets out in the cosmos.

That is why when we paint lifeless objects we must, were, reach to the light behind the surface, permeating whole surface with spirit and creating a hidden, inner ance. I could say that we must try to bring what stre down from the planets behind the surface on which paint the picture if we want it to express the reality and to be a mere copy. Thus, if we are to paint the lifeless depends on the colours being impregnated with spirit. I what does that mean?

Recall the diagram (p. 22) that I drew for you, when I sa that black is really the image of the lifeless in the spirit. V made the radiance come from the spirit and let the lifele be reflected within it. And when we colour the lifeless, whe we transform it to lustre, we evoke its essential quality This is in fact the process which we should follow when w paint inanimate things.

The next step is to ascend to the animal kingdom. I you want to introduce animals into your landscape then you should be aware—this is, of course, something to be grasped only through feeling—that the colours of the animals will have to be painted somewhat lighter than they really are and then a pale bluish light spread over them. If you want to paint, shall we say, some red animals (not very often of course!) then you must allow a light bluish shimmer to play over them and where an animal emerges from the vegetation you must blend the yellowish shimmer with the bluish, bringing about a transition from the one into the other. This will enable you to paint the animal kingdom without giving merely the impression of a lifeless copy. We can therefore say: if we paint a lifeless object it must become lustre, shining from within; if a living plant, then it must appear as lustre-image. We first paint the image colour so strongly that we go away from the natural colour. We give it the character of an image by painting

a sensitivity for the difference between image and lustre. The quality of image colour approaches more nearly to the nature of thought and the further we penetrate into the image quality the closer we come to thought. When we paint a human being we can in reality only paint our thoughts about him but these thoughts must be clearly expressed. They must be expressed in the colour. And one lives in the colour if one can say, for example, when painting a yellow surface: it ought really to be frayed out at the edges but as I am transforming it into image I must also modify it where it touches the other colours. I must apologise in my picture, as it were, for not yielding to the will of yellow.

From this you can see that it is quite possible to find a way of painting out of the colour. It is also possible to regard colour as something which accompanies the course of the earth's evolution in such a way that at first it irradiates the earth as lustre from the cosmos. Then when the elements which were within the earth were withdrawn and began to shine back from outside, colour became incorporated into material objects. By learning to experience colour in this way, by experiencing the cosmic in colour, we are able to live truly in colour itself. Living in colour means that I let the paint dissolve in my paint pot and only when I have dipped my brush in it and spread it over the surface do I allow it to become fixed. But when I use a palette and mix the colours together on it where they already have a material quality and then daub them on the surface, I am not really living in colour. I do not then live in colour, but outside it. I live in colour when I have to translate it from a liquid condition to a solid one. I can then experience, to a certain extent, how colour has evolved from the Old Moon stage of evolution to that of the Earth where it first became fixed. What is fixed can only exist upon the Earth.

In this way we gain a relationship to colour. My soul must live with the colour. I must rejoice with yellow, feel the seriousness and dignity of red; I must share with blue its

soft, I might almost say, tearful mood. I must spiritualise the colour if I am to transform it into inner capacities. Without such a spiritual understanding of colour I ought not to paint and especially not the lifeless, mineral kingdom.

This does not mean that one should paint symbolically, in a quite inartistic way: this colour means one thing, that colour something else. Colour must not be treated as if it signified anything other than itself; it must be handled so that one can live within it.

When the palette was substituted for the paint pot a real living with colour ceased and it is because of this that we have all those portraits which look like tailors' dummies. They are puppets, tailors' dummies, and the like; none of them is real or inwardly alive. Living portraits can only be painted when one really knows how to live with colour.

These then are the suggestions which I wanted to give you in these three lectures. They could naturally be expanded endlessly and this will be done at some future opportunity.[20] For the present I have tried to make these few suggestions which will serve as an introduction to further studies.

It is often said that artists have a natural fear of everything scientific and that they refuse to let scientific knowledge interfere with their art. Although Goethe could not explain the inner cause of colour as it appears in matter, nevertheless he provided the basis for an understanding. No one could have spoken more truly than he regarding the painter's fear of the theoretical when he said:

"So far there has always been found in painters a fear, indeed a specific denial, of all theoretical studies of colour and everything to do with it, for which one could not reproach them since hitherto the so-called theories were groundless, vacillating and tending towards empiricism. We should like our efforts to do something to calm this fear and to stimulate artists to experience and put to practical proof the laws we have set down."[21]

If we go about it in the right way our knowledge need not remain abstract but can be made concrete in art, and especially so in such an ever changing medium as colour. It is only through the decadence of our science that the artist, quite rightly, has such a fear of theories which have a purely materialistic and intellectual basis, particularly as we encounter them in modern optics. Just because colour is such an ever changing element it is most desirable that the painter does not allow his colour to solidify on the palette, as he usually does to-day, but keeps it fluid in the pot. It is just running away from the issue, however, when the physicist comes along and draws his lines on the board and tries to explain yellow or violet by means of these lines. This does not really belong to physics; physics is only concerned with light in space. But colour—colour can only be studied properly by taking into account the realm of soul. For it is sheer nonsense to say that colour is merely subjective. And if one goes on to maintain that there is some objective cause outside which works upon us, upon our "I" . . . this is nonsense—and implies an inadequate conception of the "I". The "I" itself is within the colour. The human "I" and astral body are not to be separated at all from colour; they live in colour and inasmuch as they are united with the colour they have an existence outside the physical body. It is the "I" and the astral body which reproduce colour in the physical and etheric bodies.[22] That is the point. The whole notion of there being an objective element in colour which has an effect upon a subjective element is thus nonsense; for the "I" and the astral body are within the colour anyway and enter with the colour. Colour actually bears the "I" and astral body into the physical and etheric bodies. The whole conception must simply be turned upside down if one is to penetrate to reality.

Everything which has thus found its way into physics and been narrowed down into lines and diagrams must be released again. It would be a good idea if for a while the drawing of diagrams were barred from physics when colour

is spoken of and the attempt made to grasp the ever changing movement and life of colour.

That is what really counts. Then one can get right away from theory and reach the artistic. Then one can fashion a method of studying colour which the painter will be able to understand because, in uniting himself with, and living in, such a method, he will discover that it is not theoretical at all but intimately bound up with colour. And when he really lives in colour, the colour will of itself be able to answer his question about the way in which it should be applied.

It means that we should try to have a conversation with the colours so that they themselves shall say how they wish to be on the surface of the picture. A method of observation which seeks to be realistic leads inevitably into the sphere of art. But the science of physics has ruined this method for us. Therefore, it must be said with all emphasis that these things which belong primarily to psychology or aesthetics should not be further distorted by a physical way of thinking but really need quite a different kind of observation.

In Goetheanism we find a way of knowledge which embraces the realm of soul and spirit but which needs to be developed further. Goethe, for example, was not able to reach the distinction between image and lustre colours. We must follow Goethe's approach in a living way in our thinking so that we can continually go further. This can only be done through spiritual science.

From a Notebook of 1921[23]

Medium: the sight is extinguished in the face of the $+$
 colours; it asserts itself in face of the $-$ colours.[24]

Red: Has overcome darkness,
 ↑ completely penetrated

Yellow: A yellow surface alters one—I must absorb
 something into myself—

Green: Plants.

Blue: A blue [*surface*] summons me to gather myself
 ↓ together inwardly—something arises from the

Red: will;
 With the yellow I am filled with something alien;
 I perceive—with blue—if I want to.

Green: Yellow and blue meet in the inner being of man.

Red: Yellow and blue act outwardly:
 blue lightened $=$ red
 yellow darkened $=$ red.[25]

Yellow: gay, noble—strength—purity—

Red: seriousness, dignity—graciousness, charm—

Blue: gentle, deep[26]

Blue—lightened to violet—it lets the light enter from outside.

In yellow something of a foreign nature arises: with it man accepts the form, which the Gods entrust to him—

In blue the soul creates itself as spirit; it imprints the outer world into itself.

In red the yellow is veiled and darkened; if red-yellow, then one enters an objective element: graciousness, charm— if yellow-red, then one is overcome: seriousness—dignity.

Black: spiritual image of the lifeless
Green: lifeless image of the living
Peach-
 blossom: living image of the soul
White: soul's image of the spirit

Black/White—Spirit/Soul

Red people in a green landscape:
 they enliven the green landscape—
Peach-blossom people:
 they are undisturbing inhabitants
Blue people:
 they destroy the landscape; they draw it with
 them into the abyss—
What is colour: picture [image],
 it acts as blue—like weeping
 it acts as red—like giving: love
 —————————

Red,
yellow: calls forth life
Blue: lets life approach it
Green: where life is extinguished
Peach- where the soul holds sway in life and everything
 blossom: dead is neutralised.

In red: traces of life appear
In yellow: life shines into death
In green: death has spread itself out—life is dried up
In blue: death appears: life opposes it
 —————————

I see red: I am filled with the radiance of the living
I see green: I extinguish the radiance of the living

Red of morning: I receive light from life—
Red of evening: I give my light to life—
 To paint the red of morning: yellow-red: it grows light
 To paint the red of evening: red-yellow: it grows dark

luminosity, as anyone with feeling for such things will recognise, and it is this which must be captured when we paint lifeless objects. When we paint out of the nature of colour and not merely by copying the outward form, we become aware of the mineral kingdom in its inner light-nature. How does the mineral become inwardly shining? If we take up a mineral, its colour is visible because we see it in sunlight. But sunlight is less active in this instance than it is with the plant. In the plant the sunlight conjures forth the other colours in addition to green. But with coloured minerals and lifeless objects generally it is the sunlight which makes the colours visible, otherwise we see no colour—just as in the dark all cats are either grey or black! But the source of the colour is, after all, within. Why? How does it get there? We are back once more to the problem from which we started out today.

When dealing with green in the plant I found it necessary to point to the exit of the moon as described in my *Occult Science*. But now I must indicate other events that have happened in the course of the evolution of the Earth.

If you follow what is said in *Occult Science* about the development of the Earth, you will find that the heavenly bodies which surround the earth and belong to its planetary system were once connected with the whole Earth; they were expelled in just the same way as the moon. This is, of course, connected with the nature of the sun; but speaking only of the Earth, we can regard it as one exodus. And this exodus of the other planets is connected with the intrinsic colouring of lifeless things. Solids have become coloured, could become coloured, because the earth was freed from those forces which were within it when it was united with the planets. These forces could then work upon the earth from outside evoking the inner power of the cosmos in the colours of minerals. This is, in fact, what the minerals received from what has left the earth and now acts from the cosmos. We see that the mystery is much more deeply hidden than it was with the green of the plant. But just because it is hidden

we are enabled to penetrate more deeply into its nature, not only into the life of the plants but right into the lifeless minerals. So in our consideration of the colouring of solid matter we come (I can only briefly mention it here) to something not taken into account at all by present day physics. We are led to cosmic effects. We cannot understand the colouring of lifeless objects at all if we do not know its connection with what the earth has retained as inner forces through the departure of the other planets from it.

We will have to explain how one mineral or another may be red, for instance, because of the interaction of the earth and one of the planets, say Mars or Mercury; or how some may be a yellow colour because of the interaction of the earth and Jupiter or Venus, and so on. The colours of minerals will always be a riddle so long as the connection between the earth and what lies outside it in the cosmos is not understood.

When we approach the living plant we must not forget how sunlight and moonlight bestow on it the colours which shine from it as lustre and the green which becomes "fixed" to the surface. But if we wish to understand what shines out from the inner nature of material objects and how the once fluctuating colours of the spectrum have now become set within solid bodies, we must remind ourselves that what is out in the cosmos today was once within the earth and is the origin of everything on earth which has a fluctuating quality, even if this is to some extent weighed down. We must look outside the earth for the cause of what lies hidden under the mineral's surface; that is the essential thing. What is found on the surface of the earth is more readily explicable in earthly terms than that which lies beneath its surface. What lies under the surface within the earth, within solid matter must be explained by what is outside the earth. Thus the mineral elements of the earth gleam in colours which they have held back from what has left the earth with the planets and these colours remain

under the influence of the corresponding planets out there in the cosmos.

That is why when we paint lifeless objects we must, as it were, reach to the light behind the surface, permeating the whole surface with spirit and creating a hidden, inner radiance. I could say that we must try to bring what streams down from the planets behind the surface on which we paint the picture if we want it to express the reality and not to be a mere copy. Thus, if we are to paint the lifeless, it depends on the colours being impregnated with spirit. But what does that mean?

Recall the diagram (p. 22) that I drew for you, when I said that black is really the image of the lifeless in the spirit. We made the radiance come from the spirit and let the lifeless be reflected within it. And when we colour the lifeless, when we transform it to lustre, we evoke its essential quality. This is in fact the process which we should follow when we paint inanimate things.

The next step is to ascend to the animal kingdom. If you want to introduce animals into your landscape then you should be aware—this is, of course, something to be grasped only through feeling—that the colours of the animals will have to be painted somewhat lighter than they really are and then a pale bluish light spread over them. If you want to paint, shall we say, some red animals (not very often of course!) then you must allow a light bluish shimmer to play over them and where an animal emerges from the vegetation you must blend the yellowish shimmer with the bluish, bringing about a transition from the one into the other. This will enable you to paint the animal kingdom without giving merely the impression of a lifeless copy. We can therefore say: if we paint a lifeless object it must become lustre, shining from within; if a living plant, then it must appear as lustre-image. We first paint the image colour so strongly that we go away from the natural colour. We give it the character of an image by painting

it somewhat darker and then spread the lustre over it: lustre-image.

If we paint animals or ensouled beings, however, we must paint the colour as image-lustre but without going so far as to make it completely image. This can be achieved by painting more lightly and transforming the image into lustre, although in doing so we introduce something that to some extent obscures its pure transparency. In this way we get an image-lustre effect.

If we now go on to what is endowed with spirit, to the human being, we must aspire to paint in pure image colour.

Mineral (lifeless)	*Lustre*
Plant (living)	*Lustre-image*
Animal (ensouled)	*Image-lustre*[19]
Man (spiritual)	*Image*

Painters working before the era of landscape painting painted in just that way; they worked in the pure image colour. Here we come to the unmixed image. This means that those colours which we have learnt to know as lustres must now be grasped as image colours. This is so because when we come to man we need in a sense to take the lustre quality from the colours and to treat them as images. Normally when we brush yellow over the surface of our picture we feel we must do so in a certain way. The yellow insists on being frayed out, as it were, and washed away at the edges; yellow will not have it otherwise. If we paint human beings, however, we find we can ignore the colour's real nature and transform it into image. When we change lustre into image in this way we approach the human and we need not worry about anything but the pure transparency of the medium when we paint human beings.

Above all one needs to develop a feeling for the change that takes place in a colour when it is transformed into image. Indeed the whole nature of colour, in so far as this is expressed in painting, becomes accessible if one develops

a sensitivity for the difference between image and lustre. The quality of image colour approaches more nearly to the nature of thought and the further we penetrate into the image quality the closer we come to thought. When we paint a human being we can in reality only paint our thoughts about him but these thoughts must be clearly expressed. They must be expressed in the colour. And one lives in the colour if one can say, for example, when painting a yellow surface: it ought really to be frayed out at the edges but as I am transforming it into image I must also modify it where it touches the other colours. I must apologise in my picture, as it were, for not yielding to the will of yellow.

From this you can see that it is quite possible to find a way of painting out of the colour. It is also possible to regard colour as something which accompanies the course of the earth's evolution in such a way that at first it irradiates the earth as lustre from the cosmos. Then when the elements which were within the earth were withdrawn and began to shine back from outside, colour became incorporated into material objects. By learning to experience colour in this way, by experiencing the cosmic in colour, we are able to live truly in colour itself. Living in colour means that I let the paint dissolve in my paint pot and only when I have dipped my brush in it and spread it over the surface do I allow it to become fixed. But when I use a palette and mix the colours together on it where they already have a material quality and then daub them on the surface, I am not really living in colour. I do not then live in colour, but outside it. I live in colour when I have to translate it from a liquid condition to a solid one. I can then experience, to a certain extent, how colour has evolved from the Old Moon stage of evolution to that of the Earth where it first became fixed. What is fixed can only exist upon the Earth.

In this way we gain a relationship to colour. My soul must live with the colour. I must rejoice with yellow, feel the seriousness and dignity of red; I must share with blue its

soft, I might almost say, tearful mood. I must spiritualise the colour if I am to transform it into inner capacities. Without such a spiritual understanding of colour I ought not to paint and especially not the lifeless, mineral kingdom.

This does not mean that one should paint symbolically, in a quite inartistic way: this colour means one thing, that colour something else. Colour must not be treated as if it signified anything other than itself; it must be handled so that one can live within it.

When the palette was substituted for the paint pot a real living with colour ceased and it is because of this that we have all those portraits which look like tailors' dummies. They are puppets, tailors' dummies, and the like; none of them is real or inwardly alive. Living portraits can only be painted when one really knows how to live with colour.

These then are the suggestions which I wanted to give you in these three lectures. They could naturally be expanded endlessly and this will be done at some future opportunity.[20] For the present I have tried to make these few suggestions which will serve as an introduction to further studies.

It is often said that artists have a natural fear of everything scientific and that they refuse to let scientific knowledge interfere with their art. Although Goethe could not explain the inner cause of colour as it appears in matter, nevertheless he provided the basis for an understanding. No one could have spoken more truly than he regarding the painter's fear of the theoretical when he said:

"So far there has always been found in painters a fear, indeed a specific denial, of all theoretical studies of colour and everything to do with it, for which one could not reproach them since hitherto the so-called theories were groundless, vacillating and tending towards empiricism. We should like our efforts to do something to calm this fear and to stimulate artists to experience and put to practical proof the laws we have set down."[21]

If we go about it in the right way our knowledge need not remain abstract but can be made concrete in art, and especially so in such an ever changing medium as colour. It is only through the decadence of our science that the artist, quite rightly, has such a fear of theories which have a purely materialistic and intellectual basis, particularly as we encounter them in modern optics. Just because colour is such an ever changing element it is most desirable that the painter does not allow his colour to solidify on the palette, as he usually does to-day, but keeps it fluid in the pot. It is just running away from the issue, however, when the physicist comes along and draws his lines on the board and tries to explain yellow or violet by means of these lines. This does not really belong to physics; physics is only concerned with light in space. But colour—colour can only be studied properly by taking into account the realm of soul. For it is sheer nonsense to say that colour is merely subjective. And if one goes on to maintain that there is some objective cause outside which works upon us, upon our "I" . . . this is nonsense—and implies an inadequate conception of the "I". The "I" itself is within the colour. The human "I" and astral body are not to be separated at all from colour; they live in colour and inasmuch as they are united with the colour they have an existence outside the physical body. It is the "I" and the astral body which reproduce colour in the physical and etheric bodies.[22] That is the point. The whole notion of there being an objective element in colour which has an effect upon a subjective element is thus nonsense; for the "I" and the astral body are within the colour anyway and enter with the colour. Colour actually bears the "I" and astral body into the physical and etheric bodies. The whole conception must simply be turned upside down if one is to penetrate to reality.

Everything which has thus found its way into physics and been narrowed down into lines and diagrams must be released again. It would be a good idea if for a while the drawing of diagrams were barred from physics when colour

is spoken of and the attempt made to grasp the ever changing movement and life of colour.

That is what really counts. Then one can get right away from theory and reach the artistic. Then one can fashion a method of studying colour which the painter will be able to understand because, in uniting himself with, and living in, such a method, he will discover that it is not theoretical at all but intimately bound up with colour. And when he really lives in colour, the colour will of itself be able to answer his question about the way in which it should be applied.

It means that we should try to have a conversation with the colours so that they themselves shall say how they wish to be on the surface of the picture. A method of observation which seeks to be realistic leads inevitably into the sphere of art. But the science of physics has ruined this method for us. Therefore, it must be said with all emphasis that these things which belong primarily to psychology or aesthetics should not be further distorted by a physical way of thinking but really need quite a different kind of observation.

In Goetheanism we find a way of knowledge which embraces the realm of soul and spirit but which needs to be developed further. Goethe, for example, was not able to reach the distinction between image and lustre colours. We must follow Goethe's approach in a living way in our thinking so that we can continually go further. This can only be done through spiritual science.

From a Notebook of 1921[23]

Medium: the sight is extinguished in the face of the $+$
colours; it asserts itself in face of the $-$ colours.[24]

Red: Has overcome darkness,
↑ completely penetrated

Yellow: A yellow surface alters one—I must absorb
something into myself—

Green: Plants.

Blue: A blue [*surface*] summons me to gather myself
↓ together inwardly—something arises from the

Red: will;
With the yellow I am filled with something alien;
I perceive—with blue—if I want to.

Green: Yellow and blue meet in the inner being of man.

Red: Yellow and blue act outwardly:
blue lightened = red
yellow darkened = red.[25]

Yellow: gay, noble—strength—purity—

Red: seriousness, dignity—graciousness, charm—

Blue: gentle, deep[26]

Blue—lightened to violet—it lets the light enter from
outside.

In yellow something of a foreign nature arises: with it
man accepts the form, which the Gods entrust to him—

In blue the soul creates itself as spirit; it imprints the
outer world into itself.

In red the yellow is veiled and darkened; if red-yellow,
then one enters an objective element: graciousness, charm—
if yellow-red, then one is overcome: seriousness—dignity.

Black: spiritual image of the lifeless
Green: lifeless image of the living
Peach-
 blossom: living image of the soul
White: soul's image of the spirit

Black/White—Spirit/Soul

Red people in a green landscape:
 they enliven the green landscape—
Peach-blossom people:
 they are undisturbing inhabitants
Blue people:
 they destroy the landscape; they draw it with
 them into the abyss—
What is colour: picture [image],
 it acts as blue—like weeping
 it acts as red—like giving: love

Red,
yellow: calls forth life
Blue: lets life approach it
Green: where life is extinguished
Peach-
 blossom: where the soul holds sway in life and everything
 dead is neutralised.

In red: traces of life appear
In yellow: life shines into death
In green: death has spread itself out—life is dried up
In blue: death appears: life opposes it

I see red: I am filled with the radiance of the living
I see green: I extinguish the radiance of the living

Red of morning: I receive light from life—
Red of evening: I give my light to life—
 To paint the red of morning: yellow-red: it grows light
 To paint the red of evening: red-yellow: it grows dark

If I paint plants: the dying away of life appears

Men: the spirit appears: flesh-colour [INKARNAT]

Colour is the appearance of life revealing itself out of the spirit (red—yellow)—that becomes fully apparent in green—releases itself—and through death (blue) returns to the spirit—lilac— . . .

The soul, when it is conscious of something objective, sends the dark (as something penetrated with spirit) towards the light which it [the soul] receives: it fills its form with flesh-colour.

The soul, when it is conscious of something subjective, sends the light (penetrated with spirit) towards the dark which it [the soul] receives: it lets its form appear in green.

Red enlivens the picture—it tears it away from the picture [image] character. It should be painted with hazy edges.

Green is a colour which wants to be laid on evenly.

Blue weakens the picture—it needs boundaries which draw into themselves so that it is darker at the edges.

Red as breath which spreads over the picture—red, but more so yellow.

Yellow demands dissolving edges, yellow is most intense in the centre.

Red acts as a still surface—in contrast to peach-blossom which condenses. [27]

Blue piles up at the edges, becomes more intense there.

Blue as surface . . .

In peach-blossom the soul is hidden

From it [peach-blossom] red is borne forth

It seizes the individual soul-nature

This finds itself filled with something alien

Red, streaming out, is orange

and, streaming in, grows yellow
Yellow is then that which fills, that
which penetrates the soul-nature, red
the soul-nature which holds itself outside
the soul, yellow within the soul, living
itself as soul. The non-ensouled,
merely living, is green. Through green
one presses into emptiness. Blue:
is that which streams away, giving place
it receives to unite.
If one remains at the same level
one comes back again to red
through violet. One becomes stiffened
in image, as one draws back
from the red, as from the fiery.
In red, however, the soul world enters in, as
in blue it recedes.

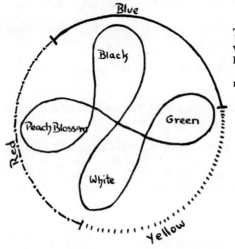

The living:
white, black, green,
peach-blossom = picture
[image]
red, yellow, blue = lustre

In red the image ceases to have its particular image character: in it the soul-nature is released as something independent.

Red represents the picture becoming living.
Green represents the living becoming picture.
Blue represents the yielding of life to the soul's becoming.

Red	Life	Life	– Red
Orange	↓ Loosing of life	Soul-nature leaving [?] life	– Red-yellow [?]
Yellow	↓ Echo of life	Life ensouling itself	– Reddish-lilac
Green	● Image	Ensouled life	– Peach-blossom
Blue	↓ Loosing of image, ensouling	Soul inspiriting itself	– Lilac-like red [?]
Indigo	↓ Soul-penetrating	Soul arising in the spirit	– Pale violet
Violet	↓ Soul-being	Soul-being	– Violet

(*See Note* 28)

Golden-yellow—coming into the sense world as red.
as foundation [*ground?*]: firm belief in the existence of the spirit as something living.

if blue-red is placed on it [*the ground?*], then just this belief in the existent spirit comes to expression.

White on Black:	Black on White:
red	blue
yellow	violet
green	peach-blossom
blue	red
violet	yellow

(*See Note* 29)

Out of white, the counter-image—green arises when the light maintains itself in the dark—the outer soul-nature (the spiritual) in the inner soul-nature.

Out of black, the image—peach-blossom arises when the

dark maintains itself in the light—the inner soul-nature in
the outer soul-nature (the spiritual).

Yellow: Lustre of the spiritual
Blue: Lustre of the soul
Red: Lustre of the living

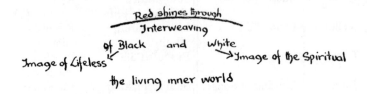

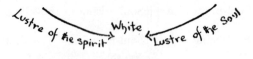

White: it transforms the image of the spirit into lustre
Yellow: it transforms the lustre of the spirit into image
Red: it transforms the lustre of the living into image
Green: it is image
Blue: it transforms the lustre of the soul into image
Peach-
 blossom: it transforms the image of the soul into lustre:
 holds together what disperses—
Black: the image of the dead as lustre.

The living strives towards colour—
 what is worn out towards abstraction, towards trans-
 parency.
Light bleaches coloured surfaces, especially yellow.

Alcohol: drives colour away
Sulphuric acid: drives colour away

The "I" sees "yellow"—it is bound to the object—the dark is however permeated with spirit—it sees its own "light".

A spectrum colour: "astral"
A physical colour: "I"

————————

Plants in darkness: white into yellow, metamorphosis is arrested.
Yellow especially dominating, blue more seldom.
Fruit green into yellow.
Warmth in water:
Light in air: transparent: sun
Chemical in water: colour: moon
Life in earth:

————————

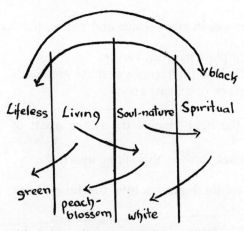

The living shines into the soul-nature red
The soul-nature shines into the spiritual blue
The spiritual shines into the lifeless yellow
The lifeless shines into the living brown

(*See Note* 30)

————————

Crime: brown black
Sin: blue
Innocence—thought: white transparent

Persuasion:	blue-violet
Necessity:	white
Compulsion:	yellow
Freedom:	black

Black substance: one enters into it, one feels the penetration—it is afire—

White substance: one must get outside it, one feels. . . .

One's own light of the retina.

Is the sense of sight capable of seeing a compound colour?

A contest of the fields of vision—

Green—? simple or compound—

Green—pigment—substance from blue and yellow.—

Goethe: he sees in green—blue and yellow, painters also—

Olive green plays in green and red—

Black and yellow (pigment) also make green.

Red and green (pigment) grey.

In green the light hinders the falling apart of blue and yellow.

In violet black furthers this falling apart.

The soul-spiritual presses into the inner being, and the colours arise.

Earth:	colouring due to the moon's exit, objects take on colour.
Moon:	there are only shining colours.
Sun:	there is only light.

♄	♃	♂	☉	♀	☿
blue	blue-red	red	yellow	yellow-red	[*no indication*]
black			white		

(♃ only darkness lightened from within)

Colour-effects of Planets and Earth together

Black-white: Earth Sun
 yields it gives
 image from the dark *lustre* from the light
 Moon lights up from within.
 ☉ white ☾ black

The moon with the inner planets lights up objects from within:

they are given spirit thereby

blue — violet — lilac

thereby the spiritual is allowed to shine in the objects, in lilac no more.

The sun with the outer planets impresses lustre on to objects:

they are given substance thereby

red — yellow — green

thereby the colours are tinged—in green no more.

black-blue	black-yellow	black-red
blue	yellow	red
from black	from black	from black

Substances appear in colour because they have released themselves from the moon—the sun can give them nothing more.

Plants appear in the colours which they retain when they are shone upon from outside by the moon—the sun gives it to them—the moon takes the light from them.

Animals bear the colours which the sun still gives them.

Warm—light [*of weight*]
 this is valid for the less heavy colours: moon turned
 away [? *new moon*]—
 Full moon: here the plants unfold their greenness—
 their colours through the sun, where they retain
 their planetary nature.

Picture through yellow glass: night-lighting.

One looks through the medium in which one is oneself—one makes the object darker.

Picture through blue glass: one makes a darker medium—one makes the object lighter—and oneself stronger.

With minerals and lifeless objects one can only paint the sun—but in a moon-scene a more imagined painting.

A plant or tree [*as a painted*] surface without the mood of sunlight is impossible—indeed plants must be painted with luminous colours.

Men painted in a moonlight mood [STIMMUNG] are impossible; one must have the opposite to the bluish "moon-mood"—bright spirit-like forms—which make no claim on the light.

Earlier painters, who paid no attention to landscape, could not paint out of their feeling for transparency because they assume the transparency of dark space; thus they could paint men in colour. The light was in the things.—

One can only paint minerals and other lifeless objects in a space shone through by the sun, thus imparting to them their inner sun-quality.

Plants should be painted in a space in which the sun is infinitely distant—so that everywhere is illumined.

Animals should be painted as if blue were shone through by red.

Men should be painted as if yellow were shone through by blue, that is really every colour in transparent darkness.

In painting minerals, the colour is painted as lustre on the surface.

In painting plants, one makes them darker than they are and paints light over them—lustre/image.

Animals are made lighter than they are and darkness placed over them. Image/lustre.

Men are treated as if they were only image.

No painting from the palette but from the pot, for the colour should only become "fixed" upon the surface.

From other Notes

Impressionism in the period of materialism = Menzel.[31]

With the transition into the spiritual, so also into Expressionism.

In the creation of the inner life of form, which is being killed through life—the mystery of Nature.

Nature is the enemy of her own being, which man can redeem—humour.—

The material world lies behind the impression and in reality one sees through the light and colour effects.

Open air painters have indeed actually darkened when they wanted to lighten; they have treated light and colour as garments, whilst they convey mysteries. One must feel the light and look through the colour. Blue, violet can never be treated as colour, but as form; only red, yellow can be handled as colour. As colour, blue pushes back the picture surface—blue has value for perspective; also because one perceives soul-nature in blue. Line and surface in sculpture: they are the means of uniting the work of art with the world. There must be awakened in the form what has been killed in nature by another [*kind of*] life.

Surface and form can be one and the same. Only a plane as surface can express something (like dark colour in painting): a plane as form would only be possible where the life of the form has died into itself. In painting the colours themselves must speak; bright colours must have a different task from the dark ones. The latter serve perspective and expression; the former release the picture into the light.

Lines and figures in the picture are always descriptive; one can only feel them in the same way as speech in man.

The picture must still have something if the lines and figures are thought away. A mere drawing with lines and figures cannot in any case be effective because of what it represents, but only through the beauty of the lines and figures; if they express something else their content destroys their form.

A beautiful woman portrayed naturalistically is killed in the picture—
A gracious woman portrayed naturalistically is not killed but murdered.
A merry peasant boy pictured on the mountain pasture is a tragedy—one must have humour to paint tragedy.

To paint a serious face is a comedy; one must have humour to portray merely a mask.

One cannot see any ice near the fire.

With Raphael, as in an earlier life—
No modern man [*painter*?], what is experienced in the first moment.
One cannot attempt to describe Raphael—the thoughts stand still.—The Moderns are either described in a self-evident manner or one feels prohibited from describing.

In relation to Raphael's work one stands in the depths of one's soul.— Amongst Moderns: one goes with the artist.

Red, yellow, etc. as colour,
Violet, blue as form.

I try to make the bright colours shine so that the light may speak; I try to fashion the dark colours into form, bring them into movement.

Line in painting: indicates something beyond the sense-perceptible.

Line in sculpture: places within the world what is formed —plane upon plane.

Thoughts stand still.

Anxiety in face of the truths of nature: one can grow pale —takes the breath away.

Art restores again.

To be ashamed: blushing as the soul's expression, makes the blood warm.

Art harmonises again.

Sense-supersense heals where sense-perceptible begins to cause disturbances.

The artist creates from nature a being or a process which oppresses us.

The artist places before us what we may take for our comfort.

These experiences are summoned on to the battlefield of consciousness at the present time.

The artist can ultimately achieve from his creative impulses something which is similar to actual existence; then he sets nature in Nature; but he does not form anything out of her.

Colour and form: perception of a creative process.

Form flows out of colour.

Contrast: colour is supported by form—or also by the "idea".

One can neither paint fire, nor draw air.

If anyone has red tableware, I surmise a gluttonous meal—with blue a hungry company.

One can expect ladies with curled hair to be pert; with violet-red dress to be haughty—clever.

The arrested vision—in its place a purpose appears—seeking form.

The arrested intuition—the "dying and becoming" of nature—listening to its secrets—striving in light or darkness.

One asks oneself, how far should one be a materialist. One may observe material processes in the course of human, physical life if one is quite clear that, through the material processes, there is reflected:

1. in perception: spirit of the outer world as bearer of the "I",

2. in conception: spirit of the past (? *pre-earthly world*: VORWELT) as bearer of the astral body,

3. in feeling: spirit of the future (? *after-world*: NACHWELT) as bearer of the etheric body,

4. in willing: spirit of the inner world as bearer of the physical body.

Colours say things which thinking does not comprehend; the language of colour does not proceed as far as thought; until blue appears.

Forms hold thought fast; it stays in the spectator-soul: it waits to be released from form.

In nature:

Plastic form is killed in favour of life and soul—

Colour is killed in favour of form.

Assymetry:

Represent so that the remnant of the sense of touch, which is in the eye, becomes effective.—Sculpture—represent so that, in the remnant of seeing in the feeling of balance, touch becomes effective.

To live in colour:

From the colour only the representation spread out in the organism.

From the representation of colour, feeling.

From the felt and represented colour, impulse.

Red-yellow: sinks itself into the organism.
Blue-red: moulds the organism.

To perceive something red-yellow: commanding.
To perceive something blue-red: receiving.

If an object appears blue to us it takes up the light in such a way that much light is absorbed and little is given back.—
In this small amount of light men see the theft of light—we lose the light element in which we live.

A blue flower lives with us in spirit.

The round form from within,
the limb-form [membered form] from without.

The artistic impulse travels from East to West—not taken directly from the antique.—
What is the consequence of this for the Renaissance?
1. In the art of the "moment" as the overcoming of space and time.

Painting: its perceptible element lies on the surface—
 its content is the destroyed 3rd dimension—
 thus colour.

Drawing only takes up the colour (the activities of the gods, who draw in space, are held and fixed).

Sculpture: its perceptible element is the spatial form— its content the non-spatial—the centre therefore composition. (One answers to what the heavens reveal.)

Poetry: Words should move upon a spiritual background, as planes before the fixed stars = Epic, or against one another = Lyric, or upon the earthly scene = Drama.

Music: The activities of the planets are held fast.

Architecture: The earth speaks (reveals itself) to Heaven.

In art man gives back again to the eternal what he has received for the earth—in Eurythmy the capacity for movement—otherwise waste.

An Answer by Rudolf Steiner

One should view the whole process of perception in its entirety:

What happens when I perceive "yellow"?

1. The eye receives from the object: *living yellow*.

2. Into this living yellow presses the perceiving subject's ether body from within; thus what proceeds from the outer ether, until then living yellow, becomes dead yellow. Thus the yellow in the eye is dead, because its life is displaced by inner life (ether-body). Thereby the cognitive subject has, instead of the outer living yellow, the image of yellow activated from within, but this image has the impress of the corpse of yellow. So far the process is objective-subjective. It would, however, only create an inwardly living yellow which the cognitive subject could not *know*. He could only *experience* his own subjective-objective processes, but not consciously.

3. Into the subjective-objective, newly enlivened yellow

presses the astral body of the cognitive subject. This creates *on* the enlivened yellow, a *living "blue"*; this blue is in fact created *within* the organism. It is present thus:

(i) The astral creates the image "blue",
(ii) The effect of the astral image on the ether body—
 as subjective life-processes,
(iii) physiologically as the physical process in the eye
 —which acts *inwardly*, *not* outwardly in blue.

All this, however, is not the object of the "I"-conscious-ness; the "I" only has knowledge of it when the living yellow in the eye is wiped out (paralysed)—then appears:

(i) Diminishing of life in the yellow through the "I",
(ii) conscious entry into the astral body of the no
 longer living yellow,
(iii) the image "blue" created by the astral, although
 remaining unconscious, shining over the dead yellow,
(iv) its effect on the subject's ether body,
(v) the physiological process in the eye.

Now, if the object, from which the yellow emanates, is removed, the "blue" image created by the astral body begins to disappear—and this dies away until the inner organism (spirit, soul and physical) has reverted to its former condition. But one cannot reverse the process of perception, because the "blue" is not a spatial entity but comes from the astral body and only its physical effect remains within the organism.

Just as the subjective blue released inwardly by the objective yellow cannot be thrown objectively on to a screen, neither can the objective process which results from the will be reversed to work back upon the subject. Otherwise, if one went forward from A to B, one would have to be able to recall the effect created *in the outer world* in retracing the path from B to A.

On Painting

Remarks made by Rudolf Steiner during the *Paedagogischer Jugendkurs* (Youth Course on Education) in Stuttgart, October, 1922. (Collected from various *Postscripts* to two lectures, 13th and 15th October, 1922.)

In art ability must be won, . . . won through work. All artistic media are exhausted (especially through naturalism).

Greek plastic art was drawn from the artist's own experience (without model). Difference in the experience of bent and stretched muscles. . . .

One must learn to live in colour so that colour can become the medium of painting. Colour experience must be permeated with soul; it must be painted out of colour. But not symbolically, that would be conceptual. Concepts have nothing to do with art, their effect is to kill all art. Concepts = passivity. The artist must, however, be active.

Starting-points for painting:

> White surface—1. surface, 2. white
> Brush and colours

A "surface" has the quality of soul: will is not expressed there. Because: unfolding of will = three-dimensional. Surface = two-dimensional—Life, primally only feeling. Will then introduced on to the surface by feeling. Introduce will into colour. . . .

Thoughts do not let themselves be introduced on to the surface; for thoughts are only one-dimensional. (Othello, grasped intellectually instead of pictorially, is given form by a continuous line.) . . .

"White" surface, this means that what is on the surface kills all colours. Death of the coloured. Through white we press as through a door into the world of colour; but it is not yet the colour world itself. . . .

If yellow is to be painted—do not only apply yellow, but live in the colour itself. . . .

To paint the mood of blue: . . . one must be able to experi-

ence the white surface inwardly each moment as pale blue. Not to make a ground of pale blue, but the colour must be in me, in my experience, and then eventually, perchance, the hand lays it upon the white surface. The soul, however, lives already in the pale blue which it can then bring forth.

The surface is one of the media which belongs to painting. . . . Spatial perspective first arose in the era of intellectualism. . . . Today one must experience perspective in colour (colour-dynamic) . . . With blue one feels: there is something behind the surface, which swallows up the surface. With red: there is something which comes towards one. The colours must both be grasped equally on the surface. It must be experienced much more richly on the surface than has been possible so far. . . .

Painting from the model is inartistic. . . . Our souls must flourish in entirely free forms.

The world of colour is itself creative, active. Blue lies back, red lies forward, through their innate colour quality. This is true colour-perspective (colour-dynamic). We feel ourselves in the surface; only will can live in space.

Form must be the work of colour. Therefore create out of the colour. In painting drawing is not true, is not there.

Learn to play with colour. In play man is most truly man (Schiller).[32] In his "Melancholia" Dürer wished to make a study in light and dark . . . a study in the revelation of light. . . .

Goethe's *Theory of Colour* is a rich mine for the painter, especially the chapter on the moral and visual effects of colour [SINNLICH-SITTLICHE WIRKUNG DER FARBEN].[33] It works right into the finger. Phantasy is always headless, it must be created through the hands. (Question for debate: Raphael without hands.) Painting is nothing if it does not give some hint of the human being in the laying on of even the most formless areas of paint, otherwise inhuman.

The question of frames: to hang a picture on the wall only

really makes sense if it has grown out of the wall. Cimabue
lets forms evolve from the gold ground; last remnant of
this; the gold frame. Frames must be coloured, harmonising
with the picture.

Painting in light and shadow is to paint the reflection of
sunlight on the object which one has set out to portray.
Still life is only experienced outwardly when placed before
one and looked at. Whereas with plants and animals, these
must be experienced inwardly.

Twofold plant: upward direction and circular direction.

Upward direction: not beautiful, inanimate, drying up,
ends in fruiting; which concludes the life of the plant. Fruit
buds—an untruth—will only be true next year when un-
folding into a new plant.

The upward striving works on from the previous year.
Leaves, tendrils, are a gift of this year. Flower, etc. is sheathed
in beauty as if remonstrating against its utility. . . .

Nature, beautiful, when she entwines herself with the
useless. . . . The colour-giving process of the flower must be
experienced inwardly. (The poppy holds its red indoors,
chicory loses its blue very quickly.)

This is artistic feeling. . . . With the inorganic, sunlight
is reflected outwardly. With the plant, one must begin to
enter its inner nature, with the animal still more, with man
entirely so. Through colour one must experience the inner
being of man. . . . One cannot experience the inner being
of animals through colour. . . . When one paints the human
countenance one must seek to penetrate the colour of the
countenance and around it to show the coloured astral
body. . . . There is nothing in nature akin to human flesh
colour, it is uniquely human. Flesh colour [INKARNAT], as
outer revelation of inner being, is entirely the creation of the
human being himself, but really only in the countenance.
The countenance is the "I". Man is human only in his
countenance and that through its colour. The outer form
of the human head reveals more that is of significance than

the brain. . . . The human head is outwardly true, although not of the earthly. . . . The feet, for example, are not truly formed, but formed in a sense out of the earth's force of gravity, . . . they are adapted to the earth. . . .

Flesh colour is no longer painted today as experience, but mostly from outside—. In Paris (Louvre) Leonardo's picture: Dionysus and John: colour still strongly felt. With Dionysus: every colour from within out; with John: every colour reflecting from outside. . . .

Mathematics comes from the limb-system, in walking, etc. In so far as it is projected into the brain do we experience mathematics. Geometry not out of the nervous system, but the nervous-system only mirror-apparatus for our soul-life.

Learn to live in the material: Rodin never lived in his material, but it is only a means of expression for him. . . . One should be able to feel how, for example, it was better to redraw the modelled forms of the *Kabyren* (Dornach)[34] instead of letting them be photographed. Photographs of a plastic form kill it. Also man when photographed appears paralysed.

Insertions in Text (Lectures, *Notebooks* and Notes) have been differentiated as follows:
 [image] = literal or alternative translation
 [*surface*] = explanatory insert, not in original text
 [INKARNAT] = German text

Bibl. = Bibliography
Notebooks = Extracts from Rudolf Steiner's Notebooks.

Whilst the Lectures and *Notebooks* in this edition are central to an understanding of Rudolf Steiner's approach to colour many other essential sources are scattered throughout his works. The Lectures and *Notebooks* also presuppose some acquaintance with Goethe's work on colour.

The Bibliography provides references to the works of Steiner, Goethe and other authors published in English.

The Notes and the General Note indicate the relationship of these works to the Lectures and *Notebooks*, and to Goethe's colour research.

GENERAL NOTE

COLOUR CIRCLE

A brief survey of the development of the colour circle may assist an understanding of the form given to it by Steiner and his references, in the lectures, to Goethe and physics.

1. *Spectrum of Physics*
.. Red –Orange–Yellow–Green–Blue–Indigo–Violet . . .
.. (760) – (687) – (589) – (527) – (481) – (431) – (393) . . .

The colours follow Newton's traditional designation and, are regarded as the subjective impressions resulting from stimulus of the sense of sight by physical movements described in terms of wavelength (typical values in brackets). This visible spectrum is regarded as part of a continuous spectrum of diverse physical effects stretching into invisible radiations on either side: radio waves, infra-red rays (visible light rays: red-violet) ultra-violet rays, X-rays. This colour scale is without Magenta-red.

2. *Colour circle and palette*

The painter has traditionally built up his palette on the three "primary" colours of Red, Yellow and Blue. By mixing, and by varying the actual "primary" pigments used, the intermediate hues are obtained. The artist's practice has led him to place his colours in a circle, bridging the ends of the Newtonian scale through Purple and Magenta-red.

3. *Goethe's colour circle*

From his study of prismatic and atmospheric colour (amongst many other aspects of colour) Goethe concluded that the colour circle was a qualitative organism. The primal phenomena (UR-PHÄNOMEN) of Yellow and Blue were his starting points (See Bibl. 1, 3, 5, 52, 53 for expositions of Goethean method and concepts). These primal phenomena arise out of the interaction of light and dark elements. Details of Goethe's observations and experiments with the prism can be studied in the works listed in the Bibliography (49, 50, 53, 54, 56, 58, and, especially, 60).

The main factors required for the annotation which follows are briefly summarised below.

Prismatic appearances are of two main types:

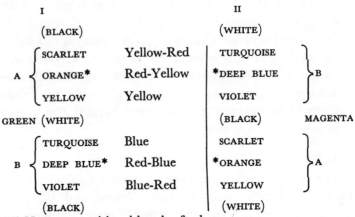

* Narrow transitional bands of colour.

When a Black/White boundary is seen through a prism two opposite colour fringes appear (A and B). These two fringes can be combined in two ways:

I. So that WHITE is eliminated: YELLOW and TURQUOISE mingle in GREEN (Goethe: *Spectrum of Light*. Newton and physics: 7-colour spectrum).

II. So that BLACK is eliminated: VIOLET and SCARLET mingle in MAGENTA (Goethe: *Spectrum of darkness*. Omitted from physical theories).

The transition in each colour fringe from YELLOW to SCARLET (A) and from TURQUOISE to VIOLET (B) Goethe regarded as a process of intensification. The effect of this progressive intensification he termed *Red*, as indicated in the alternative designation of the colours in column I. (*Elements of a Theory of Colour*, paras. 18–23: Bibl. 50 pp. 24–25; Bibl. 56 Pt. III pp. 50–52; Bibl. 58 Pt. II. pp. 170–173.)

From the primal phenomena of Yellow and Blue, Goethe built up his colour circle in the following way:

(*a*) Yellow and Blue unite *passively* in GREEN (spectrum I)

(*b*) Yellow and Blue are intensified towards Red. The

process leading to *Red* culminates in MAGENTA (spectrum II), which stands between Yellow and Blue resolving their polarity *actively*. The colour circle thus becomes an organism of related colour qualities which includes all the main hues presented by the prismatic appearances and no longer excludes Magenta-red. Goethe termed the culmination of *Red*: PURPUR (akin to the royal purple of the ancients but less bluish)—a colour that "contains partly *actu*, partly *potentia* all the other colours" (*Theory of Colour*, para. 793: see also para. 919: Bibl. 50, 56 Pt. III, 58 Pt. II).

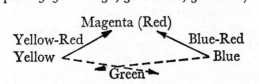

Magenta (Red)
Yellow-Red Blue-Red
Yellow ← — — — — — — — → Blue
 ← Green →

("Magenta" has been preferred to the English "purple" (for PURPUR) which varies greatly in use and often refers to a deep red-violet).

Goethe used the term *Red* in a variety of ways:

(*a*) For the colour designated SCARLET in the tabulation A above (*Contributions to Optics*, para. 59; Bibl. 50, p. 11; Bibl. 56 Pt. III, p. 23; Bibl. 58 Pt. II, pp. 140–141). At the same time the central colour of spectrum II above (MAGENTA) was termed Peach-blossom.

(*b*) Later the term "Yellow-Red" was adopted for SCARLET and "Red" was used for the effect of the process of intensification (*Elements of a Theory of Colour*, paras. 18–23; Bibl. 50, pp. 24–25; Bibl. 56 Pat. III, p. 50–52; Bibl. 58 Pt. II, pp. 170–173).

(*c*) Finally, the section headed *Red* in the chapter on the (*Visual and*) *Moral Effects of Colour* (*Theory of Colour*, paras. 792–800, Bibl. 50, pp. 37–38; Bibl. 56 Pt. III, pp. 76–77; Bibl. 58 Pt. II, pp. 194–196) is a description of PURPUR (Magenta). A qualitative distinction is also drawn between the more and less intense states of this colour (Note 26).

4. *Steiner's colour circle*

The colour circle which is built up in these lectures (and implicit in the *Notebooks*) carries the organic relationships of the Goethean colour circle into the realm of colour-being. A new relationship is presented—the contrasting qualities of the active lustre colours and the passive image colours. The varying interplay of lustre and image knit the whole into a colour circle which culminates in the subtle, fluctuating colour of human flesh or Peach-blossom colour. Nature and man are united in a single process which leads from the perceptions of the senses to "the next highest world" (p. 33). This insertion of man into nature through colour is explored from a different point of view (past, present and future) in a lecture given on 5.12.1920 (Bibl. 18).

A brief reference is required to Steiner's use of *Red* which, like Goethe's, was variable:

(*a*) as an active contrast to Green (p. 13), a colour more Yellow-Red than Magenta (Note 3).

(*b*) as a component of the warm, radiant lustre (p. 34 Lustre III, and Note 14), again a more Yellow-Red.

(*c*) as the colour in which Yellow and Blue culminate (see *Notebooks*, p. 55 and Note 25), here a Magenta-Red.

(*d*) in the *Notebooks*, p. 59, the tabulation places Red in the customary spectrum order as a Yellow-Red (Note 28), but is here associated with "Life".

Red as a lustre of the living, standing mid-way between the other two lustres, Yellow and Blue, is also the colour which, "if we select the right shade" (p. 26), shines into moving Black and White to form Peach-blossom, completing the colour circle (p. 33). This could be taken to indicate a deep Magenta-Red, the colour which appears in the first intense union of Yellow-Red and Blue-Red (see spectrum II above), which is the point of view taken in the notes provided by Julius Hebing in editing the German edition *Ueber das Wesen der Farbe* (see below p. 83, *Acknowledgments*).

This cannot, however, be reconciled with all Steiner's references to Red, as noted above, even if some are classified as Yellow-Red. More fundamentally it may obscure the true nature of Steiner's colour circle.

It is essential to recall that at different times and for different purposes Steiner approached the colour circle in various ways, the chief of which are, in time order of reference:

(*a*) Polarity of Red (advancing) and Blue (retiring)—perspective of colour: lec. 26.7.1914 (Bibl. 15, 18).

(*b*) The relationship of colour to time: past (Red), present (Green), future (Blue), man living within Peach-blossom which closes the circle: lec. 5.12.1920 (Bibl. 18).

(*c*) The relationship of lustre and image colours: lec. 2 in this volume, 7.5.1921.

(*d*) Polarity of life (Red) and soul (Violet): *Notebook of 1921*, p. 59, see also Note 28.

It is clear that Steiner's colour circle is not a physical, not a "physiological" (based on after-image contrast) nor a psychological (soul effect of colour) construct: regarded from the varying standpoints enumerated above it becomes an organism revealing the changing relationships of colour beings who are in continual movement towards and within one another. *Red* leans now towards Yellow, now towards Blue, but retaining its own character of balanced force. The radiating (*Yellow*) and retiring (*Blue*) lustres embrace, through intensification, Yellow-Red and Blue-Red aspects, meeting in *Red* actively, whilst resolving their polarity quietly in Green. Within this reciprocal activity the image colours find their own place. Further insight to that given in the Lectures is to be gained from the *Notebooks* (p. 61) where the origin of both lustre *and* image is described in terms of the four kingdoms, of the lifeless, the living, the ensouled and the spiritual. The colour circle here opens out into a realm where beings meet and reveal their nature

through their "gestures". The Lectures and *Notebooks* together allow a glimpse of a world whose activity cannot be circumscribed within a diagram or chart of colour terms but whose only entry is through experience.

COLOUR NAMES

Notwithstanding the final remarks of the preceding section the student may find the following table of colour names useful as a rough guide to the arrangement of colours in the colour circle. The left hand column has the "neutral" names of the Goethean colour circle. The right hand is a list of (water colour) paints in common use which correspond approximately to the main hues, with intermediate colours indicated to fill in some of the transitions. Colour names are legion; the list is included as no more than a serviceable starting point for further exploration of the qualities of colour (see Bibl. 51, 57, 58). Practised artists, already having their own palette, will find the list superfluous.

	Lemon Yellow
Yellow	Gamboge
	Cadmium Yellow (deep)
Red-Yellow	Orange
	Vermilion
Yellow-Red	Scarlet Lake ⎫ (commonly=Red)
	Carmine, Crimson ⎭
	various approximations:
Magenta-Red	Magenta, Purple, Rose Madder, Purple
	Madder (less commonly=Red)
	Purple Lake
Blue-Red	Mauve
	(Violet=Ultramarine + Mauve)
	Ultramarine (Indigo generally refers to
Red-Blue	black, or grey, blue)
	Cobalt Blue
	Cerulean Blue

Blue		Prussian Blue
		Viridian
Green		Hooker's Green (deep)
		Sap Green
		Lemon Yellow
(Yellow)		(Gamboge)

The transition from Yellow-Red to Blue-Red above embraces only the more intense states. The transition through the delicate nuances of Peach-blossom are hinted at in the right hand column of the tabulation in the *Notebooks* (p. 59) and can only be realised through experiment with paler washes of Reds, Purples and deep Blues.

ACKNOWLEDGMENTS

The translator gratefully acknowledges the valuable assistance of members of the Mercury Arts Group (London) and the Goethean Science Foundation (Clent, Worcs.) in criticising text and Notes, and his debt to the authors of the works in English listed in the Bibliography. The Notes are partly based on the most valuable compilation provided by Julius Hebing (for *Ueber das Wesen der Farbe*, Stuttgart, 1959) with some change of emphasis (see Colour Circle (iv) above) and a number of additions.

CONCLUSION

In the absence of a comprehensive course by Rudolf Steiner on colour and painting, comparable to those given in other fields of art and science, the attempt has been made in this edition of three fundamental lectures, with the extracts from the *Notebooks*, to provide such other supplementary material as will afford a point of entry for the English reader to a rich field of exploration.

It is no purpose of the Notes to put a particular interpretation on one aspect or another, only to put before the reader the material he may need to form his own judgment and, more important, to gain his own practical experience in the insubstantial, yet vital, realm of colour. The Notes and references are intended as servants to that end.

NUMBERED NOTES

1. *He, to whom nature . . .* From *Sprüche in Prosa* (Bibl. 48, Vol. 4, Part 2, p. 494).

2. The three contrasts may be regarded as examples of the main types of colour combination characterised by Goethe. (*Theory of Colour*, paras. 803–829; Bibl. 50, 56 Pt. III, 58 Pt. II).
 Green/peach-blossom : harmonious combination
 Green/(yellow-) red : characteristic combination
 Green/blue : non-characteristic (monotonous) combination
 See also *The Creative Power of Colour*, chap. 2 (Bibl. 51). Red is in this case more inclined towards the yellow side (see General Note).

3. *They have no inner connection with the green meadow.*
 The question here is how eye and feeling react to the movement between one colour and another.
 (Yellow-) red on green creates spirited, positive activity.

Blue on green creates diminished, negative activity.

Peach-blossom on green is calm, balance, harmony.

(See also Note 2.)

4. See *Theosophy*, chap. The Constitution of the Human Being. (Bibl. 7.)

5. *Image* has been used to translate BILD [=picture] in the sense of a representation or semblance of another entity. The image colours have this quality in contrast to the lustre colours (described later). This becomes clear from the analogy to the portrait (later) which is not to be confused with the person whom it pictures or *images*.

6. In characterising the nature of the image colours Steiner uses various descriptions:

Lecture 2: 1st para *. . . one form of existence is taken up in another.*

2nd para *. . . distinction between that which gives and that which receives, between that element in which the image is formed and that which causes the image.*

3rd para *. . . distinguishing the shadow-thrower from the illuminant.*

These may be grouped as follows to bring out the underlying relationship:

one form of existence	another form of existence
that which gives	that which receives
cause of image	element in which image is formed
source of illumination	shadow-thrower

The diagram at the end of Lecture I shows how each element can take on the first function and then the second. Isolating the movement from one element to another which produces each image colour, we may say:

one form of existence (active)→	\| that which receives	\| result	
or: source of illumination →	\| thrower of shadow	\| image	

7. This and subsequent passages should not be thought of in terms of a physical experiment where rays of yellow and blue light are projected on to a white screen. The hues of yellow and blue which, when projected in this way, overlap to make white are said to be complementary by the physicist. Steiner is here referring to the inner activity of yellow and blue as lustre colours in the way which is developed later in this lecture. The artist is concerned with the way these colours, when brought together in a simple mixture, form green on a white ground. It is evident from the latter part of this lecture that Steiner considers this mixing of yellow and green to be something more than the laying of indifferent flat washes of colour one upon another, but rather the mingling of polarically opposite activities. Hence the dynamic description here of yellow and blue imaginatively creating green on a white surface.

8. . . . *to choose the right shade* . . . This seems to imply a colour nearer to Goethe's magenta-red [PURPUR] rather than a hot yellow-red. (See General Note.)

9. *This process* . . . In lectures to doctors and medical students (Bibl. 26) Steiner refers to these processes in the human organism; also in lectures on 5th and 10th December 1920 (Bibl. 18, Pt II).

10. *Red . . . the balance between these two* [*yellow and blue*]. See General Note.

11. . . . *through its stillness* (ALS RUHIGE RÖTE). The use of the word RUHIG here appears to refer to the motionless quality of a red surface hence the rendering "still" rather than "quiet" or "peaceful" which would be incompatible with the more familiar description a few lines further on that red "asserts itself".

12. *Image colours* [BILDFARBEN]: *lustre colours* [GLANZFARBEN]. Literally "picture colours" (Note 5) and "gleam colours". It is the dynamic quality of the latter, actively shining, which is distinguished from the passive, reflective, more

representational character of the image (picture) colours.

13. ... *variations of something that shines* [LEUCHTENDES]. This is different from the sources of illumination referred to at the beginning of this Lecture. In Lec. 3, the sun is spoken of as the illuminant, and the three lustre colours are modifications of this.

14. This indicates diagrammatically the structure of the colour circle which Steiner builds up in this passage.

The customary colour scale is analysed into two lustres (III and IV) and an image colour (II). These two lustres correspond to the two colour fringes which Goethe describes as intensifying towards red (see General Note).

... Red–Orange–Yellow–Green–Blue–Indigo–Violet ...

| Lustre III | Image II | Lustre IV |
| radiating | | encrusting |

The third lustre which stands between the other two (yellow and blue) and lies behind the formation of peach-blossom is not yet fully present in this scale of colour (see General Note).

The drawing together of the two ends of the colour scale, the interplay of the lustre red and the images black and white in peach-blossom leads to "the next highest world"—see also final para. of this Lec. Here Steiner completes the process begun by Goethe in his (*Visual and*) *Moral Effects of Colour* (Bibl. 50, 56 Pt. III, 58 Pt. II). The soul's reaction to colour is heightened until colour itself is recognised as the substance of the soul world.

What appears in the diagram has been worked out as a *process* (for use as a painting exercise) by Hilde Boos-Hamburger in *The Creative Power of Colour*, Exercises 33–36 (Bibl. 51).

15. *You must destroy* . . . See the description of the process of perception in the *Notebooks* (pp. 70–71).

16. See chap. *The Evolution of the World and Man* (Bibl. 11).

17. This passage contrasting the "representation" [VOR-STELLUNG] of a stool with an "image" [BILD] of it invites the question: what is the difference? The answer may lead to a fuller appreciation of the term "image". To the painter it is important that the whole surface of the picture should be "alive". Steiner points out that this living quality is imparted to inanimate objects (in a painting) through a lustre effect. Van Gogh's paintings of chairs and the like may convey what is meant by "representation" of inanimate objects. If only image colours had been used (in an image manner) there would be a mere lifeless "image", a visual shell.

18. . . . *our building* . . . The Goetheanum, Dornach, near Basle, Switzerland. The first building to bear this name was burnt down on New Year's Night, 1922–23. It was constructed largely in wood to Steiner's design. The two large interlocking cupolas were decorated in broad sweeps of colour with themes depicting the spiritual evolution of mankind. The paints used were made from plant colours according to Steiner's direction. Steiner's colour sketches for both cupolas of the first Goetheanum have been published, see Bibl. under *Colour Sketches*.

For further information on the first Goetheanum, see Bibl. 15, 27.

19. *Lustre—image: image—lustre*. The reversal of terms implies a change of direction in movement. The lifeless mineral has its image quality lifted into lustre. The *darkened* image of the plant is bathed in the outwardly shining lustre (yellow); it is brought towards lustre but retains its image quality. The *lightened* animal form is subdued by the inwardly shining lustre (blue) towards image, whilst retaining its lustre quality. The reduction of all colours to image, eliminating lustre, is appropriate to the human form.

Mineral	(image)	:	lustre
Plant	lustre	–	image
Animal	image	–	lustre
Man	(lustre)	:	image

20. See Bibliography for references to further reading, particularly *Colour* and *Anthroposophy and Art* (Bibl. 18, 35).

21. See Bibl. 49 (para. 900).

22. See *Notebooks*, description of the process of perception (pp. 70–71).

23. *Notebook of 1921*. The notes—with slight deviations and omissions—are given in their original sequence. The single pages (sides) of the *Notebooks* are indicated in this edition by a line:

Where two sides belong together as far as content is concerned they are shown as a single unit.

The individual notes which follow the *Notebooks of 1921* are of a more general, artistic interest. Although they are drawn from other sources they are relevant to the lectures in this volume, as are the postscripts to two lectures of 13th and 15th October, 1922, on painting, also included.

24. + *Colours*, − *Colours*. See Goethe's *Theory of Colour*, paras. 764, 777 (Bibl. 50, 51, 56 Pt. III, 58 Pt. II).

25. *Blue lightened = red*
 Yellow darkened = red

 This appears to be a reference to the process of intensification culminating in magenta-red (see General Note).

26. See Goethe's *Theory of Colour*, chap. 6: (*Visual and*) *Moral Effects of Colour*, paras. 764–798 (Bibl. 50, 51, 56 Pt. III, 58 Pt. II).

 The qualities of the three colours in this Note closely follow Goethe's characterisation. The red that Goethe

describes in the passage to which these *Notes* relate is
PURPUR (Magenta-red), the culmination of the redden-
ing process which he characterises as follows:

> The effect of this colour is as unique as its nature. It
> gives an impression of *seriousness* and *dignity* as well as
> *graciousness* and *charm*. It serves the first in its dark and
> intense state, and the latter when it is light and
> diluted. And thus the dignity of age and the grace of
> youth can don the same colour.

Goethe here distinguishes between the qualities of the
first intense hue resulting from the union of yellow-red
and blue-red (General Note) and the lighter hue into
which this disappears when the band of colour is
narrowed in the prismatic appearance.

Following on the preceding passage (refer Note 25) the
red mentioned here by Steiner would also appear to be
a magenta-red. However, the immediately succeeding
passage where these qualities are related to red-yellow
and yellow-red indicate a warmer red.

27. . . . *peach-blossom which condenses*. The expression "con-
denses" may here be understood in the sense of the
contrast between "lustre" (red) and "image" (peach-
blossom). "Image" colour is, compared with "lustre",
more condensed. See Lecture 2 (pp. 29–30) where the
relation between red and peach-blossom is explored.

28. The [?] inserted in the third column indicates that the
word "leaving" [VERLASSEND] in the original could not
be deciphered with certainty. At the other two [?] in the
fourth column the names of the colours are questionable.
This tabulation presents a further version of the colour
circle. On the left the customary colour scale from red
to violet, on the right the subtle changes from red,
through peach-blossom to violet, in which five steps are
noted. The whole forms a twelve-fold differentiation of
the colour circle.

This arrangement appears to be based on the polarity

of life (red) and soul (violet) and the reciprocal movements between them.

Red-yellow [?] in the right-hand column contradicts the evident movement from (dark) red to (dark) violet through lighter nuances of peach-blossom. Despite the lack of unequivocal colour names for the intermediate steps the progression intended is clear enough. The colour names in the left hand column are those of the traditional spectrum. In this context red would be a deep yellow-red, i.e. a warm red unmodified by blue and not a hue standing midway between yellow and blue. It appears here, however, as the lustre of life. (See General Note.)

29. These two columns are Goethe's spectrum of light (left-hand column) and spectrum of darkness (right-hand). (See General Note.)

30. This scheme brings together the genesis of both image and lustre colours out of the four underlying elements which appear in Lectures 1 and 2 in connection only with the image colours. (The diagram and the text beneath belong together.) The arrows without colour names attached are those relating to the tabulation below, except that the last note referring to brown has no corresponding arrow in the diagram.

31. Menzel, Adolf Friedrich Erdmann von (1815–1905). German lithographer and painter, well-known for historical illustrations, of the period of Frederick the Great, and court painting: also creator of more unorthodox interiors, street scenes and landscapes reminiscent of Honore Daumier.

32. Schiller. The reference is to his *Letters on Aesthetic Education* where Schiller's theme is the role of art as educator. Between the compulsions of reason and desire lies the realm of art where, through play, man learns to create and experience freedom. See also *Goethe's Standard of the Soul*, Chap. III, (Bibl. 6), in which Steiner examines Goethe's Fairy Story of *The Green Snake and the*

Beautiful Lily and Schiller's *Letters on Aesthetic Education.*

33. See Bibl. 49, 50, 51, 56, 58.

34. Kabyren. Figures produced in connection with a production of Goethe's *Faust*: see *The Goetheanum Windows* (Bibl. 59) for illustration of sketch for Kabyren (Cabireans).

Rudolf Steiner

Writings and lectures (published in translation) related to the content of this volume are listed below. The list is not exhaustive. Readers of German will find more extensive reference in the Bibliographies contained in—

 Das Wesen der Farbe, R. Steiner (Dornach 1973).

 Die Schoepferische Kraft der Farbe, H. Boos-Hamburger (Basel, 1959).

References are given in date order of original publication or of original delivery of lecture(s), indicated in brackets after the title.

1. The Theory of Knowledge implicit in Goethe's World-Conception (1886), New York, 1968.
2. Goethe as the Founder of a New Science of Aesthetics (1888), London, 1922.
3. Goethe the Scientist (1883–97: see ch. 15–17), New York, 1950.
4. The Philosophy of Freedom (1894), London, 1964.
5. Goethe's Conception of the World (1897: see pp. 139–168), London and New York, 1928.
6. Goethe's Standard of the Soul (as illustrated in Faust and in "The Fairy Story of the Beautiful Lily") (1902: see ch. 3 for reference to Schiller, Note 32), London, 1925.
7. Theosophy (1904), London, 1965.
8. Spiritual Hierarchies (1909: see lec. 2), New York, 1970.
9. The Gospel of St. Luke (1909: see lec. 1), London, 1964.
10. The Nature and Origin of the Arts (1909), London, undated.
11. Occult Science (1910), London, 1963.
12. Metamorphoses of the Soul (1910: see lec. *The Mission of Art*), London, undated.
13. Spiritual Beings (1912: see lec. 1), London, 1951.
14. Secrets of the Threshold (1913: see lecs. 5, 6), London, 1928.
15. Ways to a New Style of Architecture (1914: see lec. 5), London and New York, 1927.
16. Technology and Art (28th December, 1914), publ. in *The Golden Blade*, 1959.
17. Art in the Light of Mystery Wisdom (1914–23: see lecs. 1, 2, 3, 5), London, 1970.
18. Colour (1914–24), London and New York, 1935.
 Pt. I The Nature of Colour (3 lecs. in the present volume)
 Pt. II Colour in Light and Darkness: Dimension, Number,

Weight (3 lecs. 5th, 10th December, 1920, 29th July, 1923)

Pt. III The Creative world of Colour.

(lec. 26th July 1914, also in Bibl. 15, lec. 5: extracts from other lecs. including Bibl. 35, 41).

19. Festivals of the Seasons (see lecs. April–May 1915), London and New York, 1928.

20. Memory and Habit (1916: see lec. 3), London, 1948.

21. Karma of Vocation (1916: see lec. 6th November), London, 1944.

22. Lucifer and Ahriman (1919: see lec. 9th November), London, 1954.

23. The Mysteries of Light, of Space and of the Earth (1919: see lec. 13th November), New York and London, 1945.

24. Supersensible Experiences (18th January 1920), publ. in *The Golden Blade*, 1960.

25. Natural Science and its Boundaries: Paths to the Spirit in East and West (2nd–3rd October 1920), publ. in *The Golden Blade*, 1962.

26. Spiritual Science and Medicine (1920: see lecs. 2, 6, 11, 14, 16), London, 1948.

27. The Architectural Conception of the Goetheanum (1921), London and New York, 1938.

28. At the Centre of Man's Being: I, II (23rd–24th September 1921), publ. in *The Golden Blade*, 1963.

29. The Concealed Aspects of Human Existence and the Christ Impulse (5th November 1921), London and New York, 1941.

30. Man's Life on Earth and in the Spiritual World (1922: see lec. 2), London, 1952.

31. Man and the World of Stars: The Spiritual Communion of Mankind (1922: see lec. 7), New York, 1963.

32. Truth, Beauty, Goodness (19th January 1923, also included in Bibl. 17), London and New York, 1927.

33. Education and Art (25th March 1923), London, undated.

34. The Cycle of the Year (1923), London, 1956.

35. Anthroposophy and Art: Anthroposophy and Poetry (1923: extracts also included in Bibl. 18, Pt. III), London and New York, 1935.

36. Education and Modern Spiritual Life (1923: see lec. 5th August), London, 1954.

37. The Arts and their Mission (1923), New York, 1964.

38. The Four Seasons and the Archangels (1923), London, 1968.

39. Man as Symphony of the Creative Word (1923), London, 1970.
40. Mystery Centres (1923: see lecs. 23rd, 24th, 25th November), London and New York, 1943.
41. Christian Rosenkreutz (1924: see lec. 4th January, extract also included in Bibl. 18), London, 1950.
42. Eurythmy as Visible Speech (1924: see p. 208–216), London, 1956.
43. Speech and Drama (1924: see lec. 14), London, 1960.
44. Karmic Relationships, Vol. II (1924: see lec. 17), London, 1956.
45. Ascension and Pentecost (The Festivals and their Meaning: III) (1908–24: see lec. 4th June 1924), London, 1958.
46. The Course of my Life (1923–25: see chap. 5, 21, 22), New York, 1970.
47. Fundamentals of Therapy (*with* Ita Wegman) (1925: see chap. 4, 5), London, 1967.

Colour Sketches

The following collections of Rudolf Steiner's sketches in colour are included because of their interest to the student, although not published with English text.

Sketches for the first Goetheanum

Zwölf Entwürfe für die Malerei der grossen Kuppel des ersten Goetheanum. Dornach, 1930.
(12 designs for the paintings of the Large Cupola of the First Goetheanum.)

Rudolf Steiners Entwürfe für die Malerei der kleinen Kuppel des ersten Goetheanum. Dornach, 1962.
(Rudolf Steiner's designs for the paintings of the Small Cupola of the First Goetheanum.)

Painting Exercises

Neun Schulungsskizzen für Maler "Naturstimmungen". Dornach, 1962.
(9 Exercises for Painters : Nature moods.)

Goethe

Principal works on Colour appear in Vols. III and IV of:

48. *Goethes Naturwissenschaftliche Schriften* (*Goethe's Natural Scientific Writings*) 1883–1897 (Kürschner) edited by Rudolf Steiner, whose introductions elucidating Goethe's scientific method have appeared in English as *Goethe the Scientist* (Bibl. 3).

English translations:

49. *Goethe's Theory of Colour*, trans. C. L. Eastlake, London, 1967, F. Cass U.S.A. 1970, Massachusetts Institute of Technology.

50. *Goethe's Approach to Colour*, trans. E. C. Merry: NKB*, 1959. Contains extracts from Goethe's principal works on colour:
 1. Contributions to Optics. paras. 1–22.
 2. Researches into the Elements of a Theory of Colours. paras. 1–45.
 3. A Theory of Colour, (from chap. 6) The Moral Effect of Colour, paras. 758–888, 915–920 (formerly published as Pt. III of *Pure Colour*, Bibl. 56).

Other Authors

51. H. Boos-Hamburger: *The Creative Power of Colour*, London (Mercury Arts Group) 1963: with 66 Exercises, illus. in colour.

52. W. Heitler: *Man and Science*, Edinburgh and London, 1964 (see chap. 2: *Goethe versus Newton*).

53. E. Lehrs: *Man or Matter*, London, 1958 (see chap. XIV–XVIII).

54. L. Loynes: *The Spectrum*, London (Byraz Colour Bureau) 1959 (also as Supplement to *Byraz Colour Co-ordinating*, 1959).

55. E. C. Merry: *Art, its Occult Basis and Healing Value*, NKB*, 1961: illus. in colour (contains Pt. II of *Pure Colour*, Bibl. 56).

56. E. C. Merry and M. Schindler: *Pure Colour*, London, 1946: illus. in colour.

57. G. Mayer: *The Mystery-Wisdom of Colour*, NKB*, 1961: with 29 Exercises, illus. in colour.

58. M. Schindler: *Goethe's Theory of Colour Applied*, NKB*, 1964: with 14 groups of Exercises, illus. in colour (formerly Pts. I and III of *Pure Colour*, Bibl. 56).

59. A. Turgeniev: *The Goetheanum Windows* (with personal reminiscences of Rudolf Steiner's explanations on the theory and practice of glass engraving), London and New York, 1938: illus. in colour.

60. M. Wilson: *What is Colour?*, Clent, Worcs. (Goethean Science Foundation) 1949.

 *NKB=published by New Knowledge Books, East Grinstead,

OTHER BOOKS ON ART

Animal Metamorphoses (folder) *Gerard Wagner*
Black and White Shaded Drawing *Valerie Jacobs*
A Glance into Nature's Workshop (folder) *Gerard Wagner*
Imagery of the Goetheanum Windows (folder) *Wilhelm Rath*
Rudolf Steiner's Sculpture in Dornach *Fant, Klingborg, Wilkes*
Stave Churches in Norway *Dan Lindholm*
Work Arising from the Life of Rudolf Steiner *ed. John Davy*